Judith Shea

KENT
Fine Art LLC

Published on the occasion of the exhibition *Judith Shea* at Kent Fine Art,
May 9 through June 29, 2014

Kent Fine Art
210 Eleventh Avenue
New York, NY 10001
www.kentfineart.net
212-365-9500

ISBN 978-1878607-31-7

First edition: 1000 copies
Edited by Jeanne Marie Wasilik
Chronology by Jeanne Marie Wasilik
Co-Designed by Aya Rodriguez-Izumi and Katrina Neumann
Photo Essay (cover and p.3-39) by Elyse Harary/Orlando Tirado
Printed by Permanent Printing Limited, China

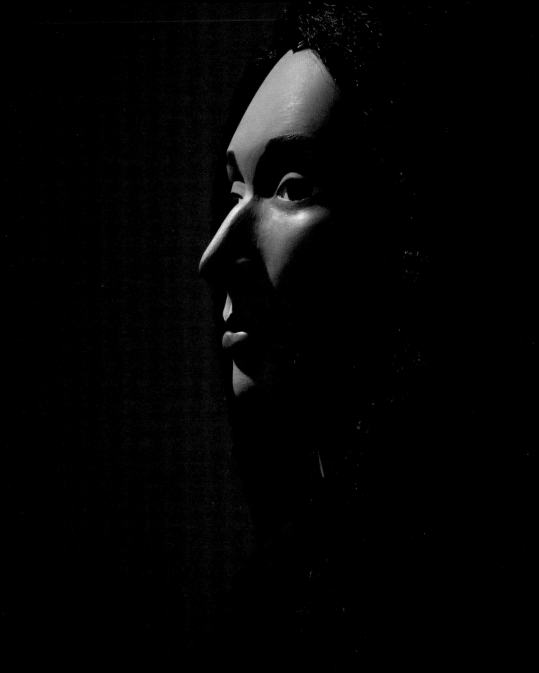

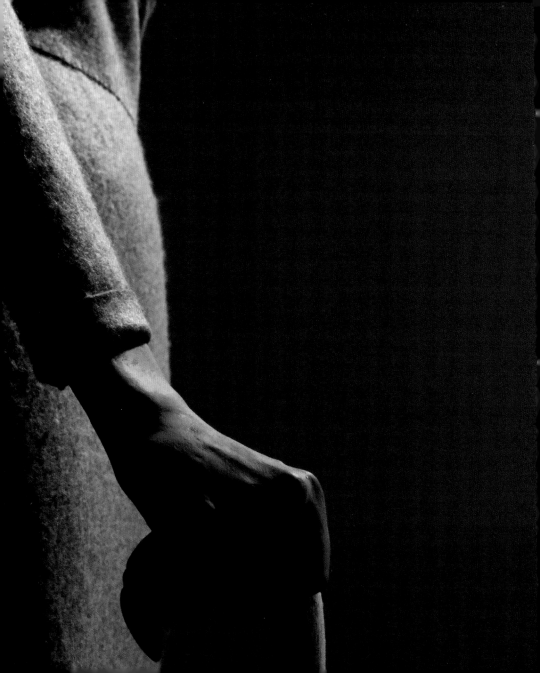

Judith Shea

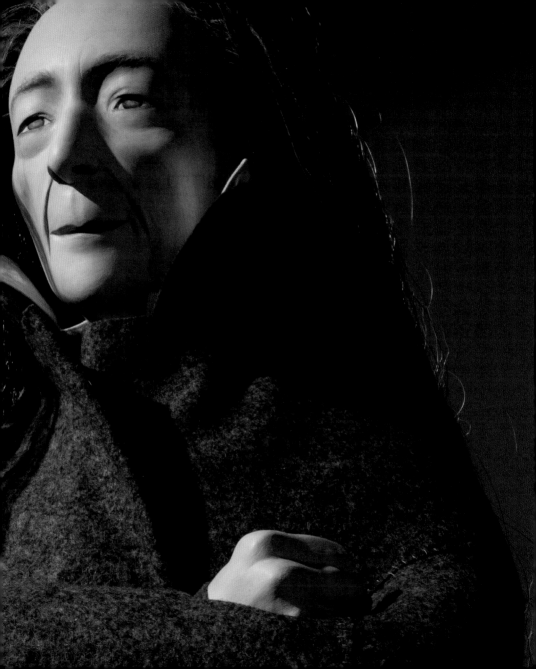

WORKS EXHIBITED

EASY DOES IT

COCO'S CONSEQUENCE

MARISOL

ELIZABETH TRIBUTE

LOUISE MONUMENT

STUDY (FEMALE)

STUDY (MALE)

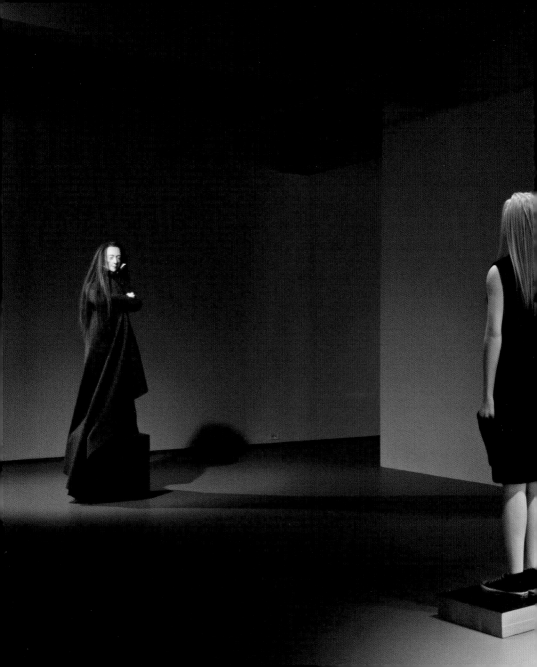

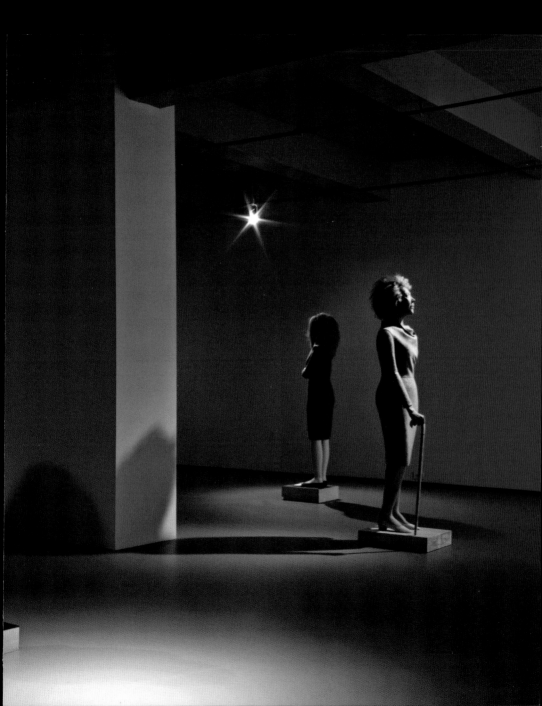

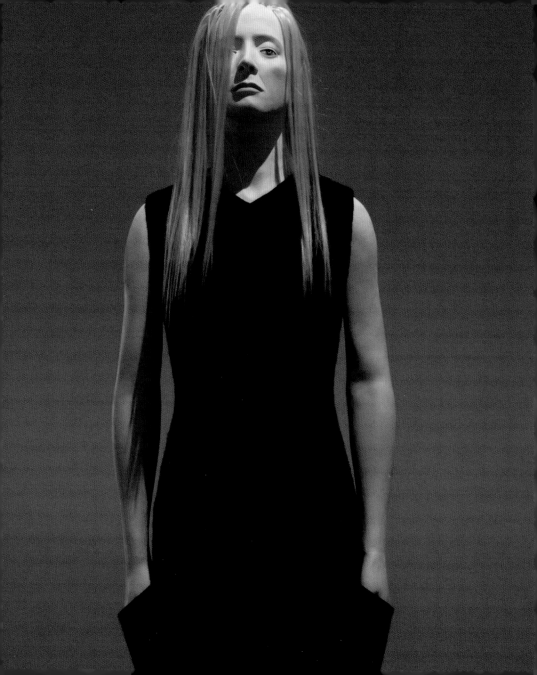

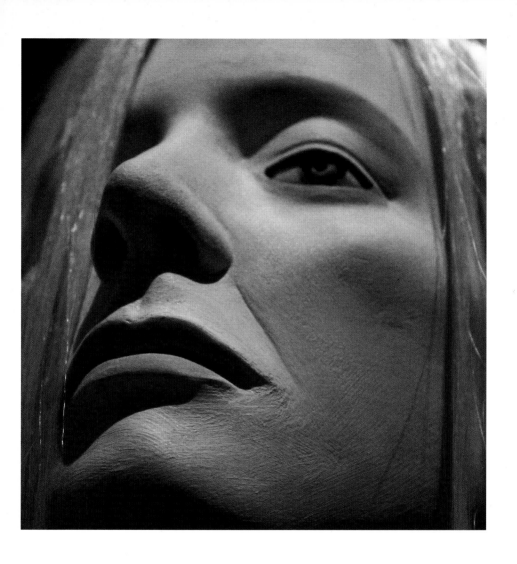

Easy Does It

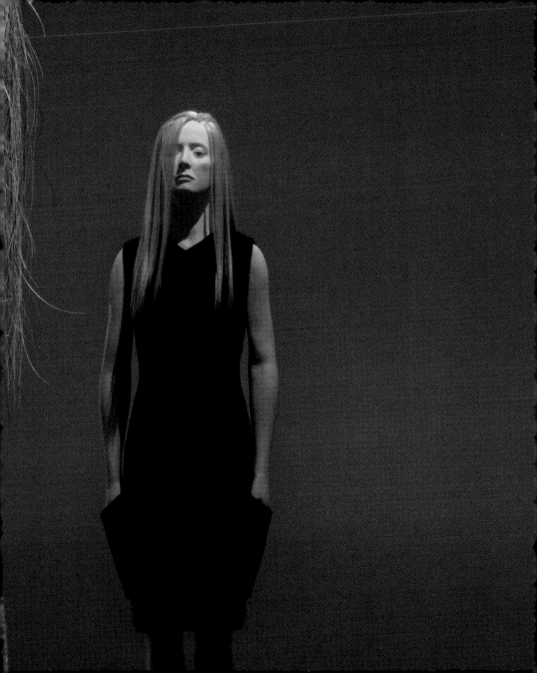

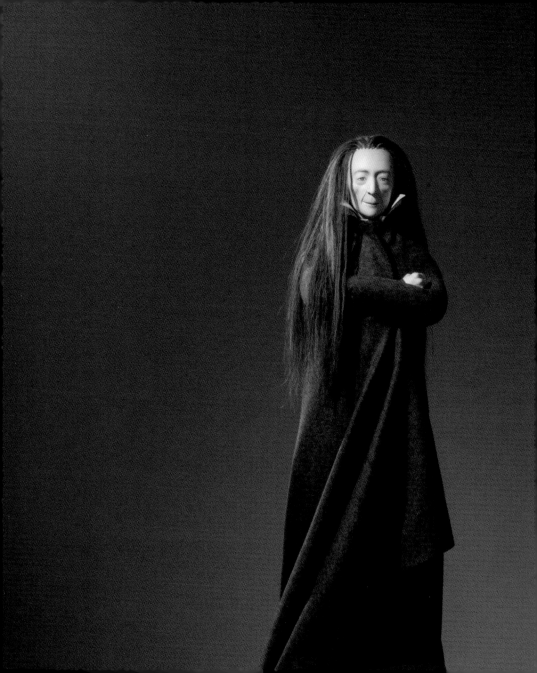

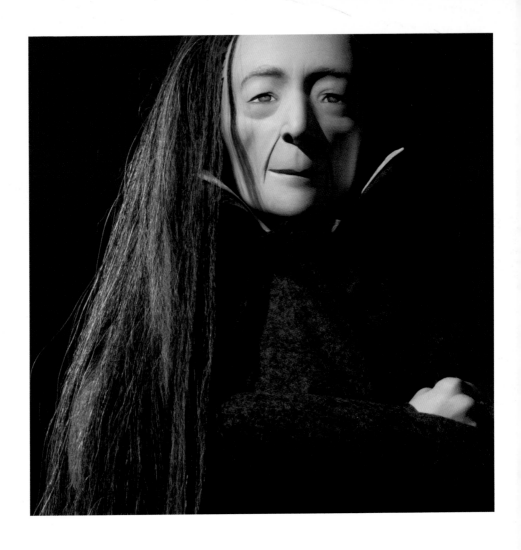

Louise Monument: Portrait of Louise Bourgeois

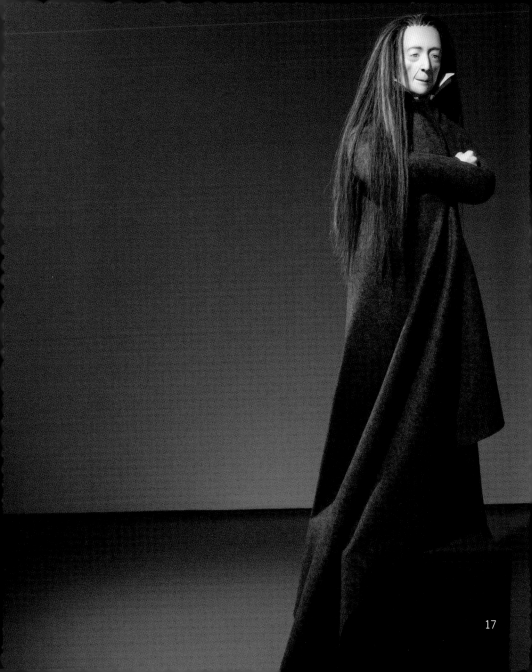

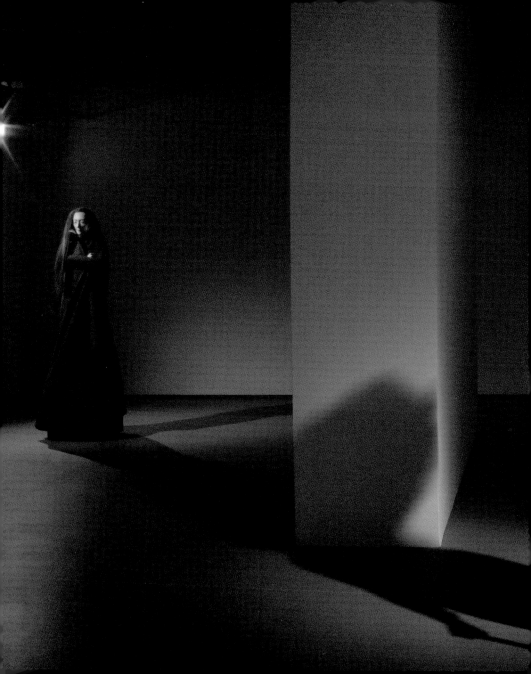

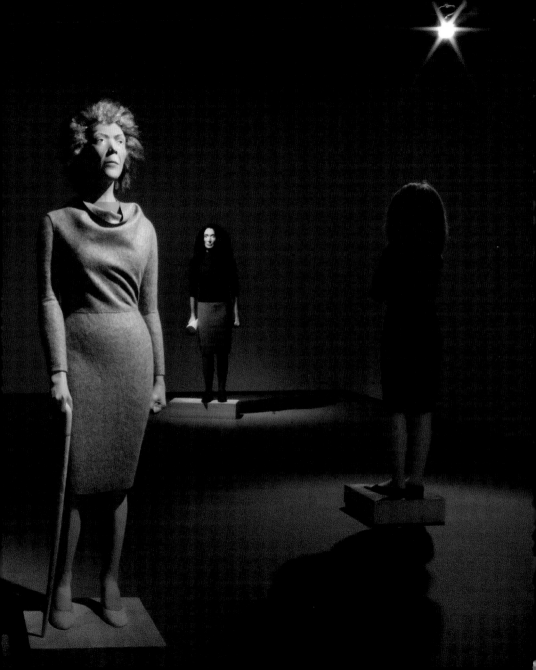

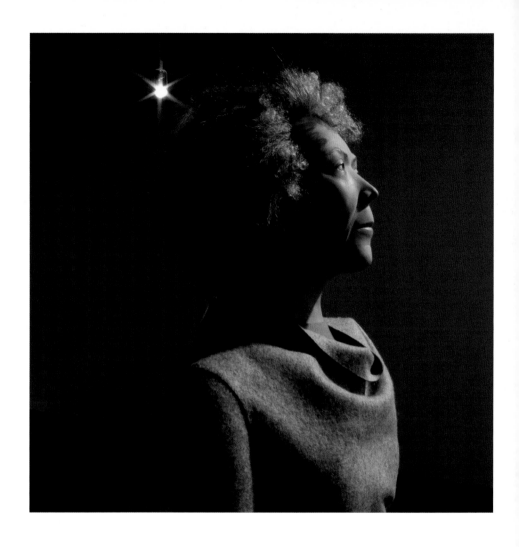

Elizabeth Tribute: Portrait of Elizabeth Catlett

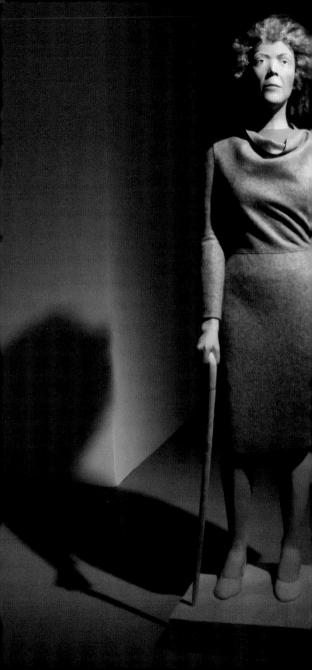

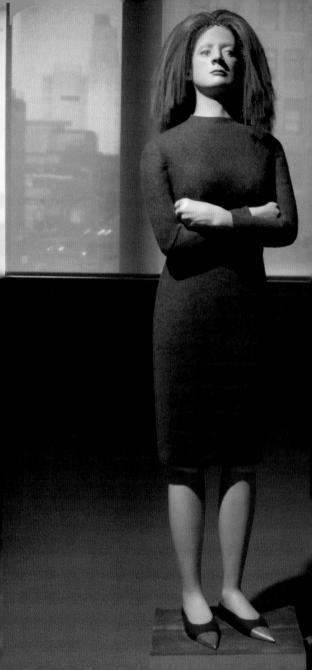

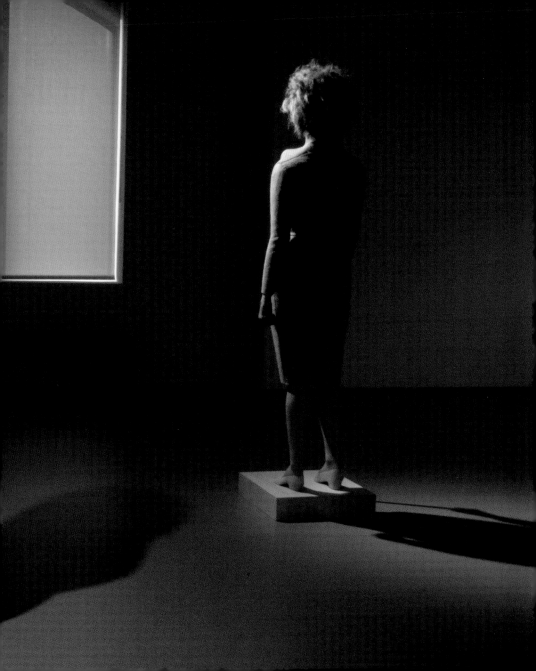

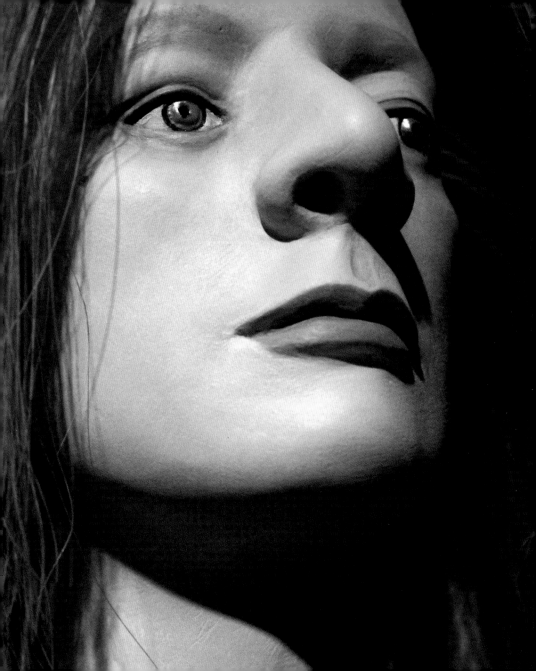

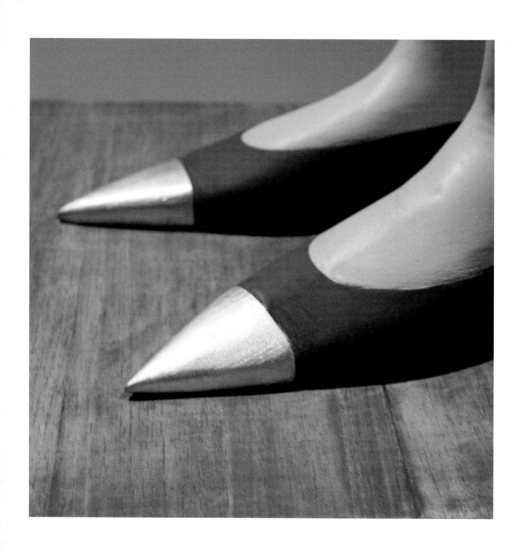

Coco's Consequence

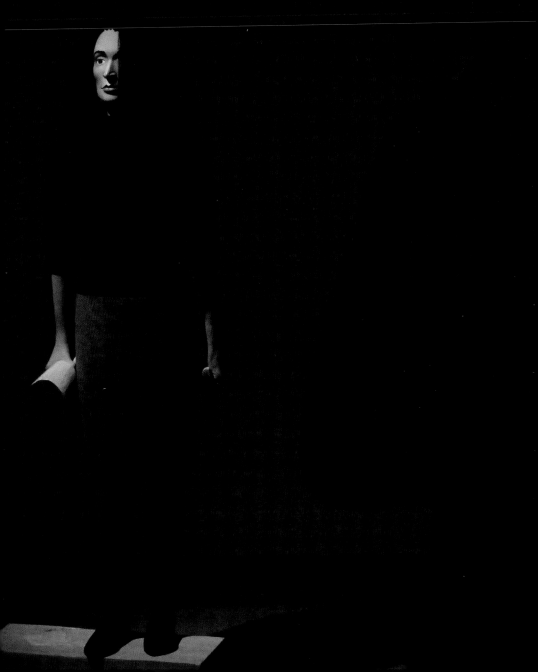

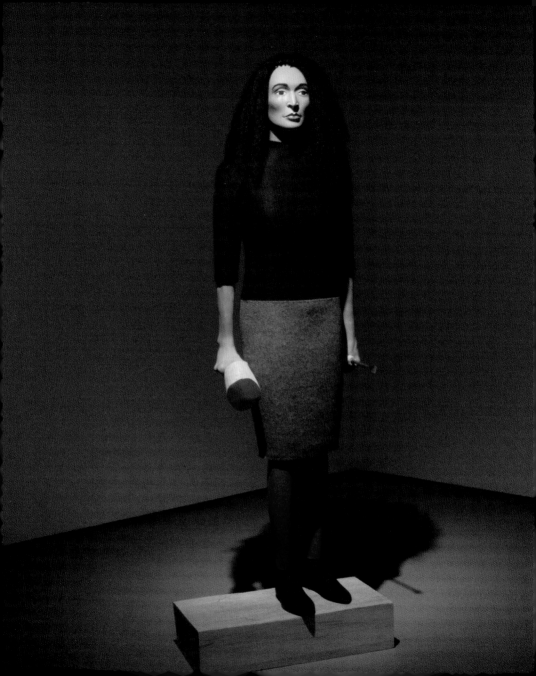

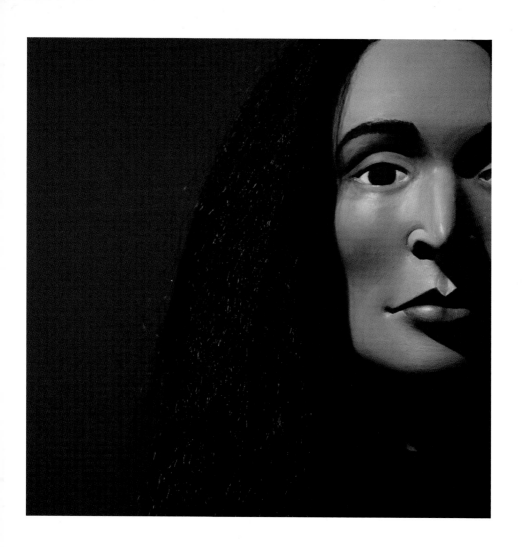

Marisol

Study (Female)

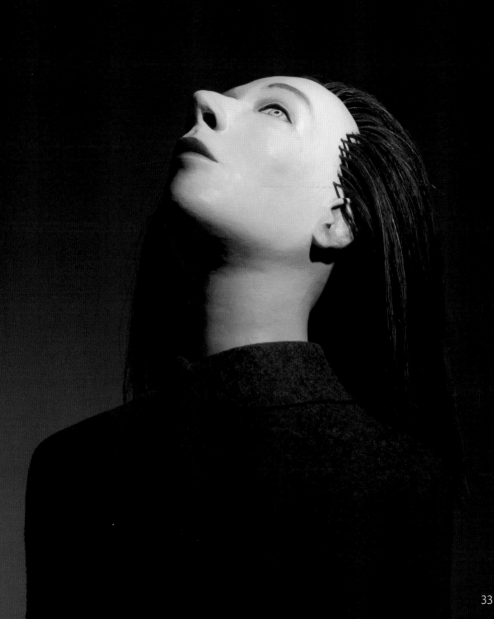

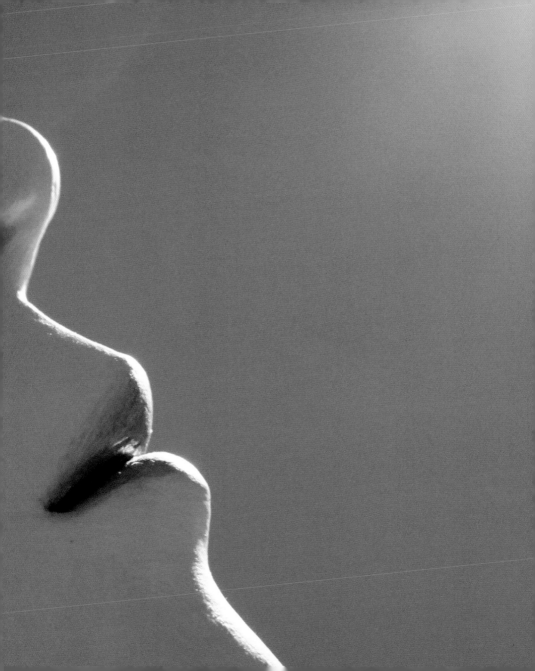

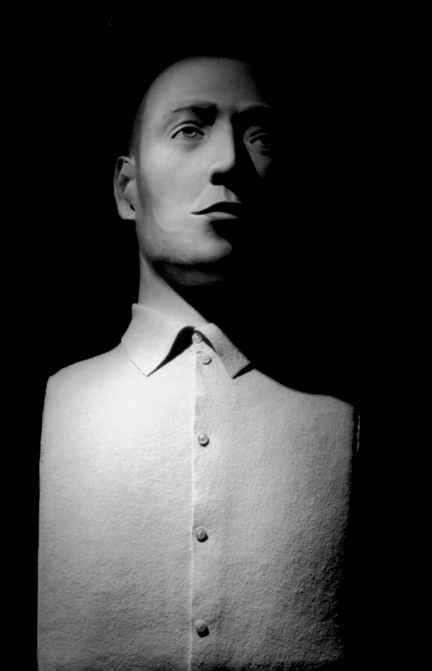

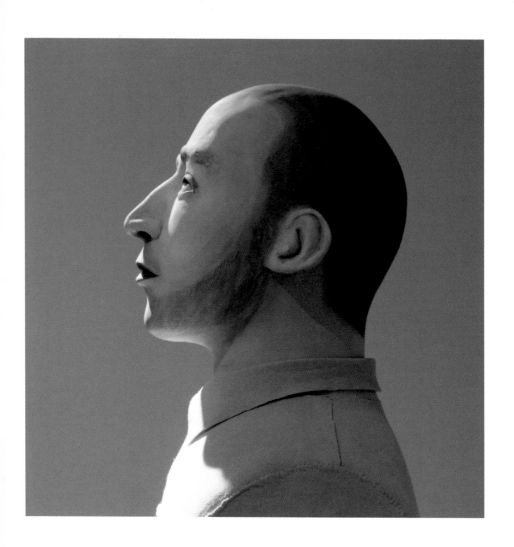

Study (Male 2)

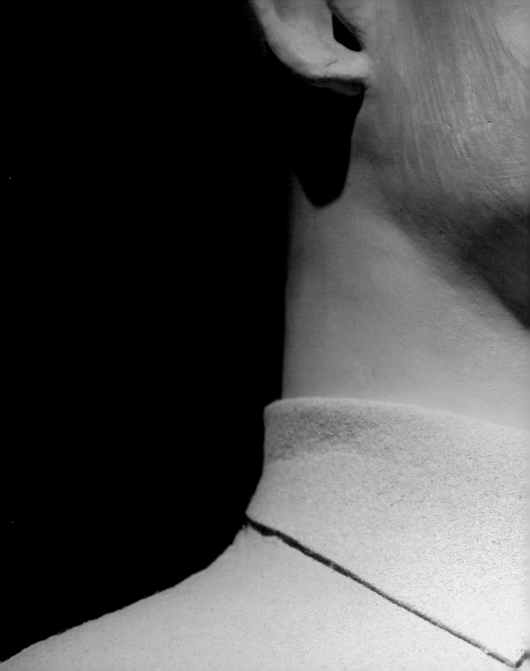

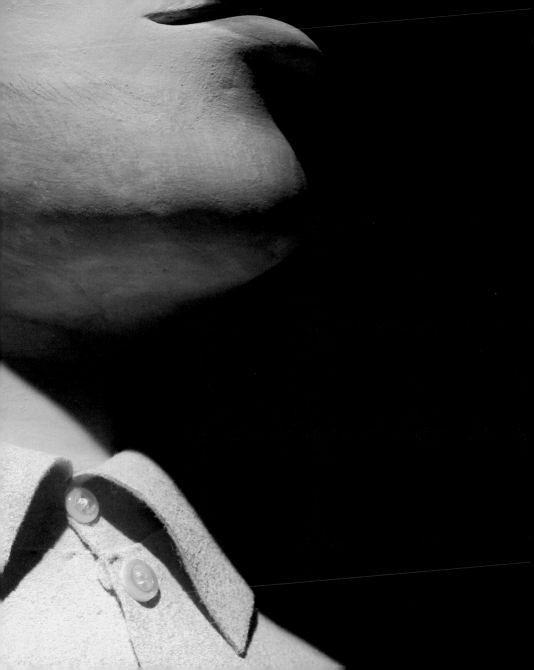

The heads in this show are all made out of very fine Japanese cellulose based clay, which is air-dried. I make a rough casting out of a rubber mold of a generic female head. When the clay is dry and the parts are put back together into a head form, I carve, cut, grind, sand, re-model, and re-shape the face, ears, and sometimes the shape of the head to what I want, using the clay in both a dry and wet state. When the clay is dry and the surface is cleaned up and sanded to a smooth finish, then I paint it, the face especially.

Finally, after sketching the shape of the hairline, and figuring the amount of hair to be used, the holes for the hair plugs are drilled and cleaned out. Meanwhile, the hair has been separated from large tails, or cut from wigs, and made into individual hair nibs, or plugs. These will eventually be inserted into the drilled holes in the head using archival glue. This is close to the last step, and then the hair is cut, shaped, and groomed.

In the case of the three portraits, it is the same process, except that the re-working is toward a specific likeness, which, of course is much more demanding and is usually redone many times.

Unlike carving a "statue" out of a whole piece of wood or stone, the torsos, arms, and legs are all made separately. The separate pieces have to be fitted together to make a convincing figure in terms of anatomy, pose, and balance.

The "clothing" is then made directly on the figure. There are no patterns. I work the material right over the torso–clipping, stretching, and sometimes shrinking it over the form. It gets finalized and held in place by sewing it together with hand-stitches. Oftentimes the individual parts are "dressed" separately, like the "sleeves" that cover the arms, for example. This happens after the pieces have been fitted together, though not attached. After all the parts are covered, everything goes together and is permanently attached. The last step is to hand-sew the remaining seams, and attaching the parts of the cloth surface.

I try very hard to make the "clothing" in a way that is not like real clothes. I think of the clothes as sculpture, as they are derived from the technology I developed to make my previous hollow-form figural work in bronze. I use fabric that is not made for clothing, like industrial felt, rough hand-stitching, and seam lines that are not accurate to real clothing patterns, but rather create formal notations. For example, the use of a straight center seam down the front or back of the figure, an aesthetic choice that is like a surveyor's plumb line, makes one aware of formal issues, like the balance and overall composition in the work.

<div align="right">Judith Shea</div>

CHECKLIST

Easy Does It, 2014
Carved polystyrene foam, carved balsa wood, felt, paper clay, paint,
rubber, synthetic hair, and modified Converse All Star sneakers
69 1/2 x 20 x 16 in.

Louise Monument: Portrait of Louise Bourgeois, 2011–12
Carved polystyrene foam, carved balsa wood, felt, paper clay, paint, cotton,
and horsehair
75 x 18 1/2 x 18 1/4 in.

Elizabeth Tribute: Portrait of Elizabeth Catlett, 2012
Carved polystyrene foam, carved balsa wood, felt, paper clay, paint,
and synthetic hair
74 x 18 x 19 3/4 in.

Coco's Consequence, 2013–14
Carved polystyrene foam, carved balsa wood, felt, paper clay, paint, silver leaf,
and horsehair
69 1/2 x 16 x 15 3/4 in.

Marisol, 2013
Carved polystyrene foam, carved balsa wood, felt, paper clay, paint, steel,
and synthetic hair
70 x 24 x 14 in.

Study (Female), 2007–12
Carved polystyrene foam, wood, felt, paper clay, paint, and horsehair
18 x 12 1/2 x 11 in.

Study (Male 2), 2009–11
Carved polystyrene foam, wood, felt, paper clay, and paint
22 x 11 1/2 x 9 1/2 in.

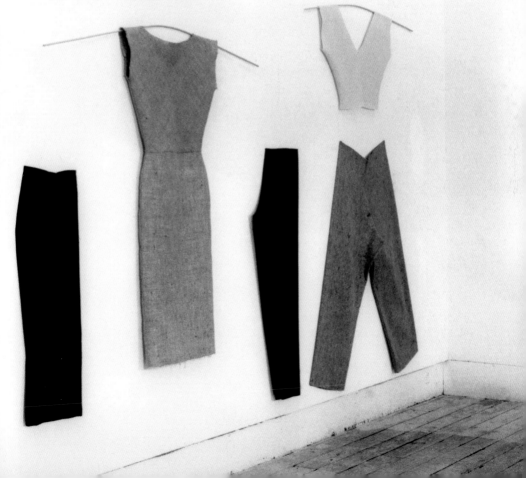

TIMELINE
SELECTED WORKS
1976 - 2012

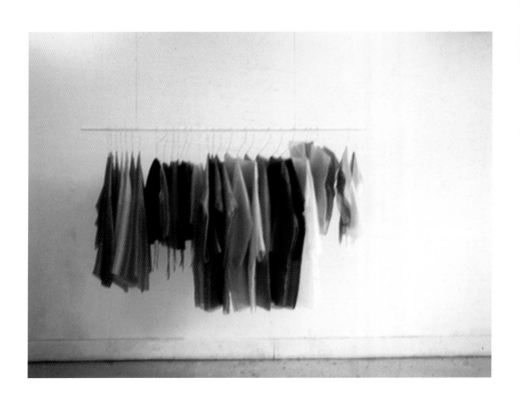

Project Studio: The Clocktower

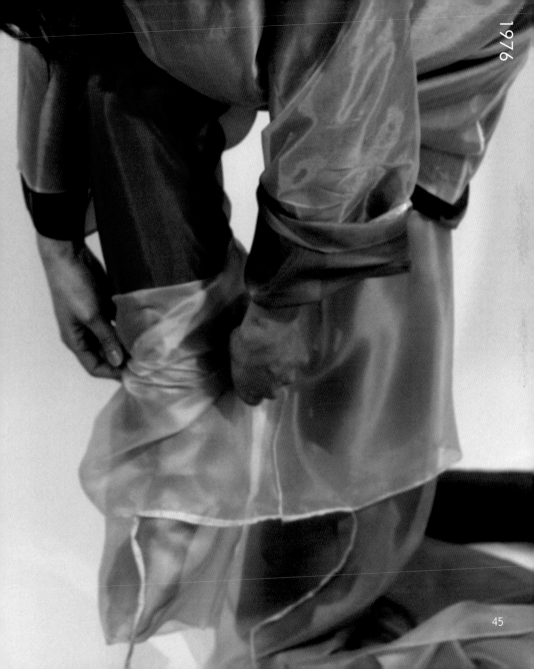

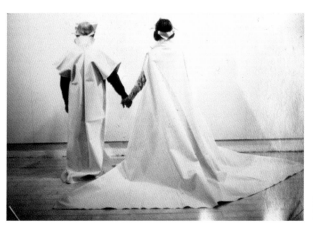

King and Queen

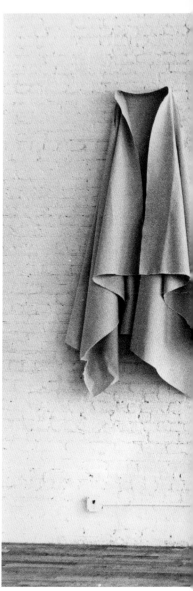

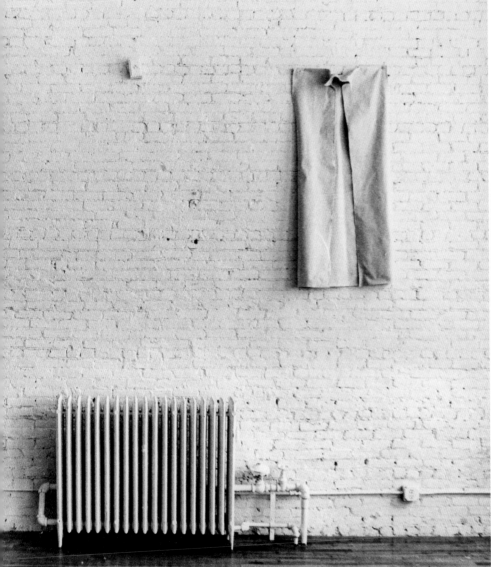

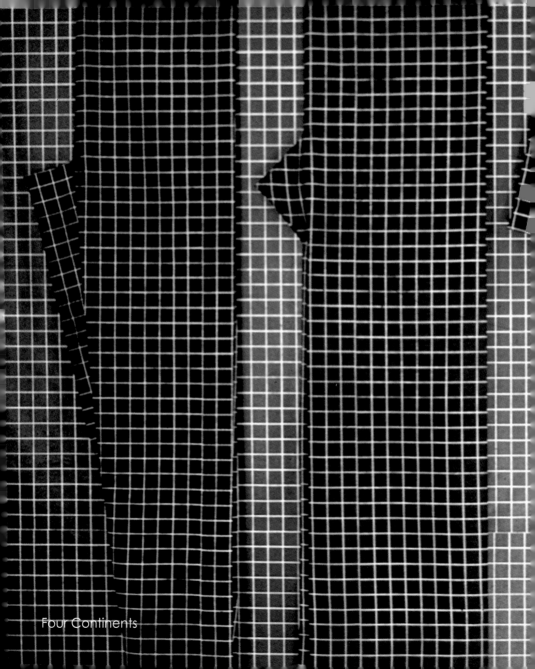

Four Continents

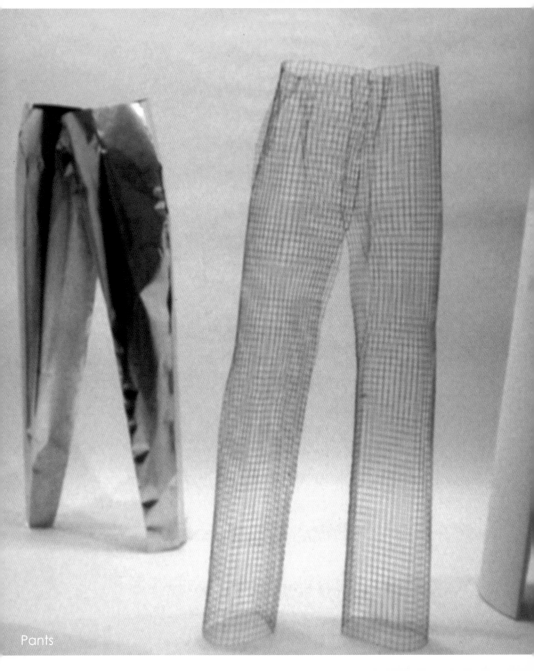

Pants

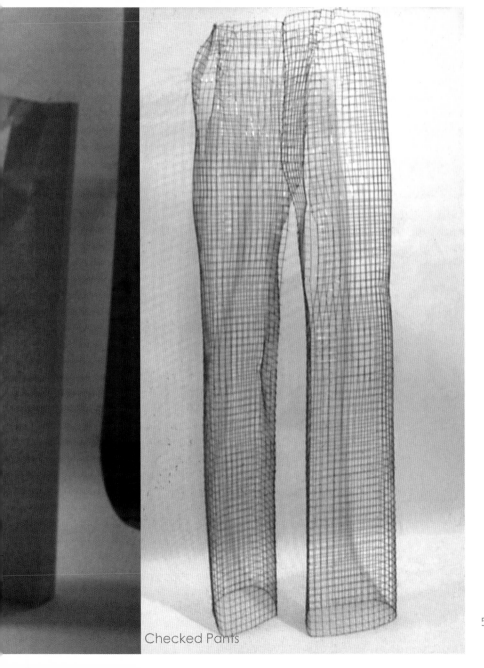

Checked Pants

51

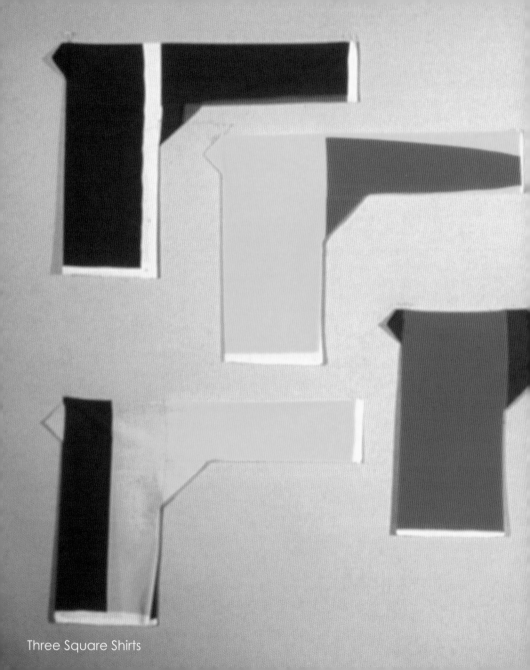

Three Square Shirts

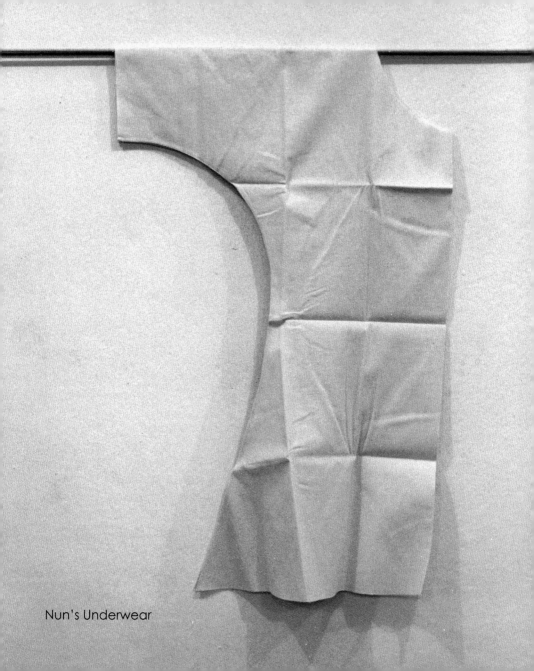

Nun's Underwear

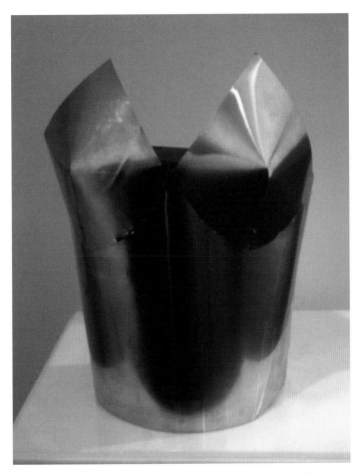

High Hat

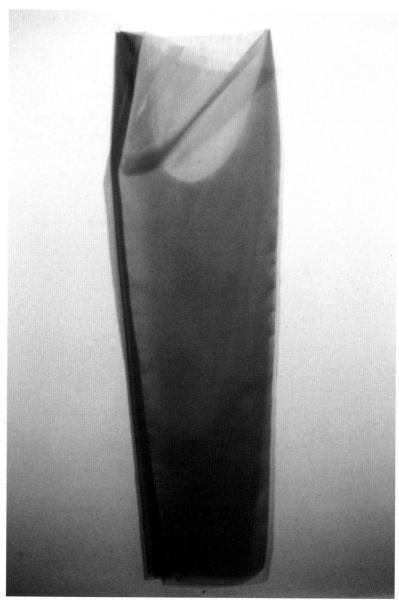

Katharine Hepburn

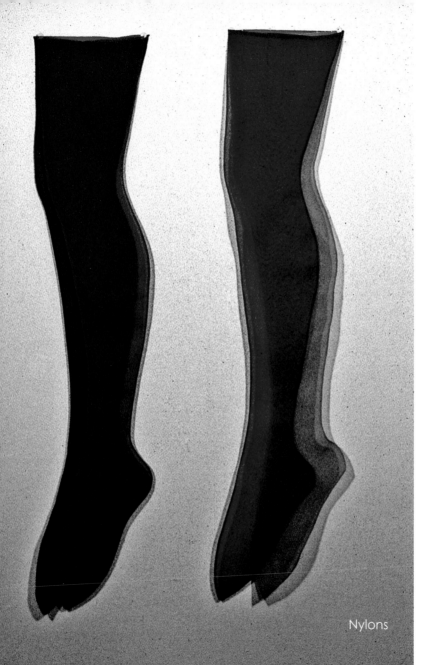

Nylons

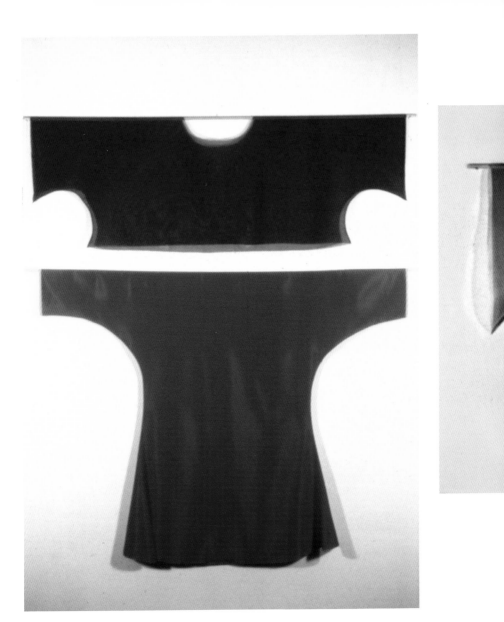

Pope

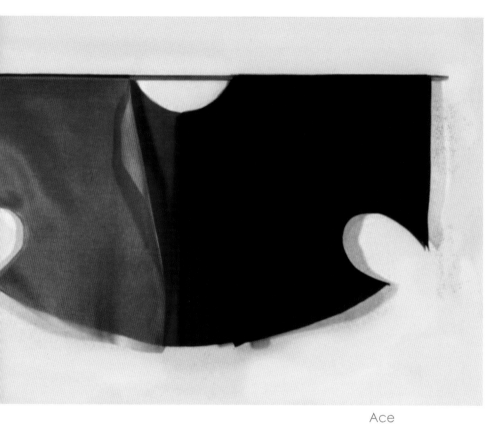

Ace

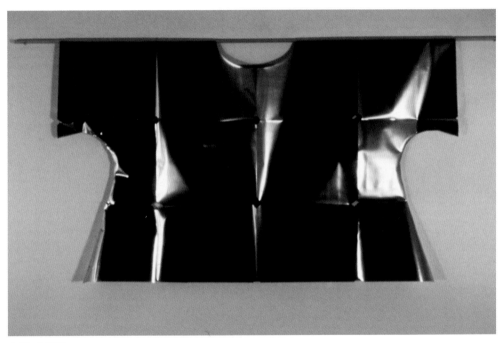

A.D. 1980

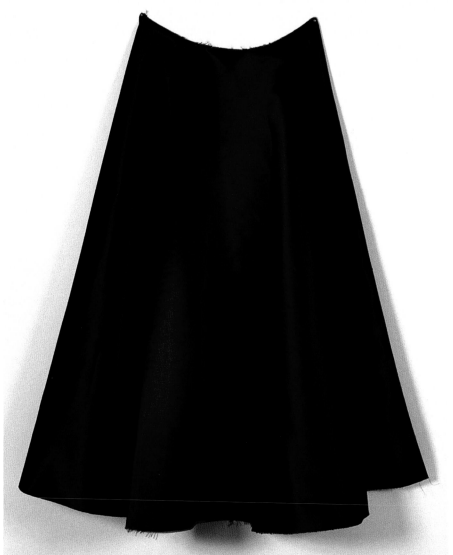

Bop

Exec. Sec'y

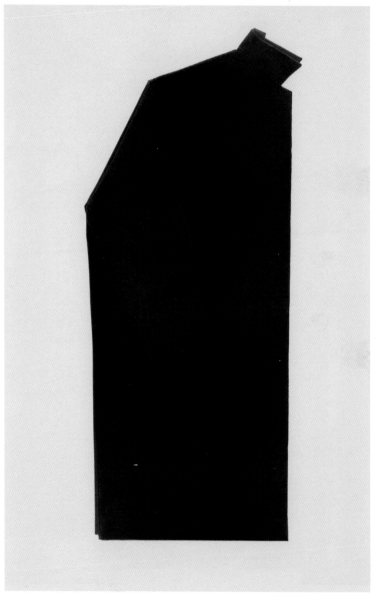

I Like Ike

O Kazimir

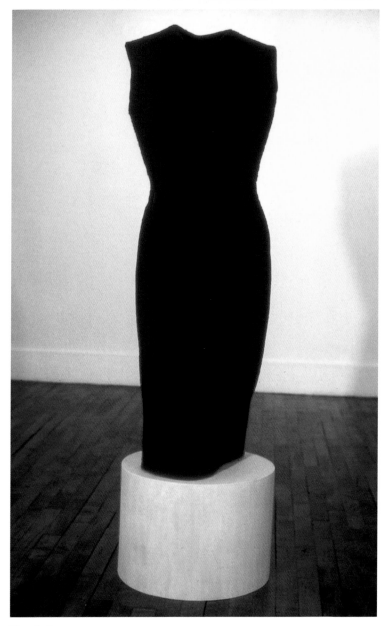

Black Dress

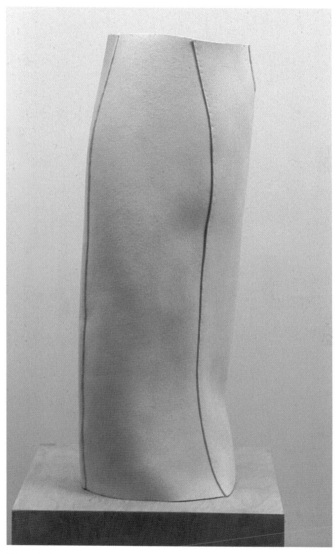

Plumbline

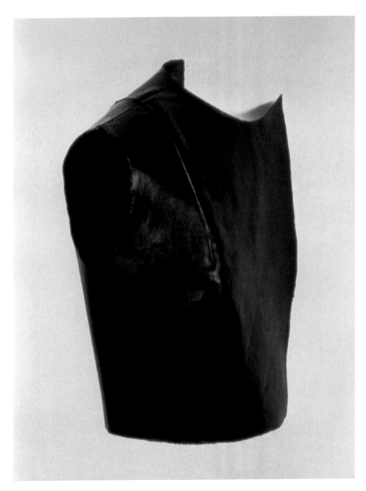

Proxy

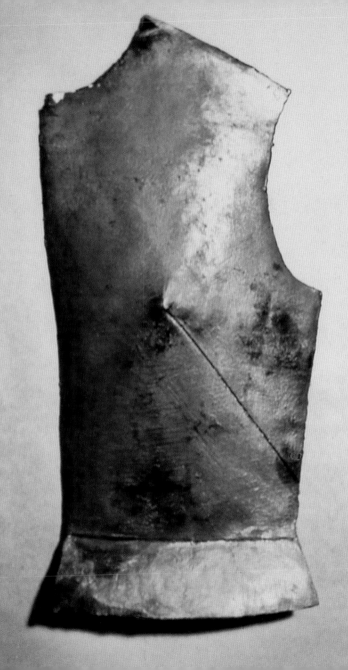

Peplum

Crawl

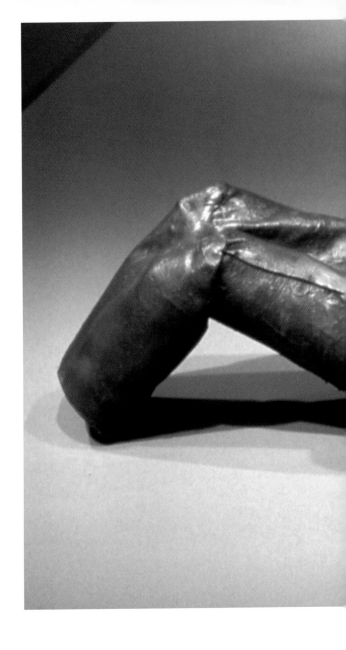

Acting Out

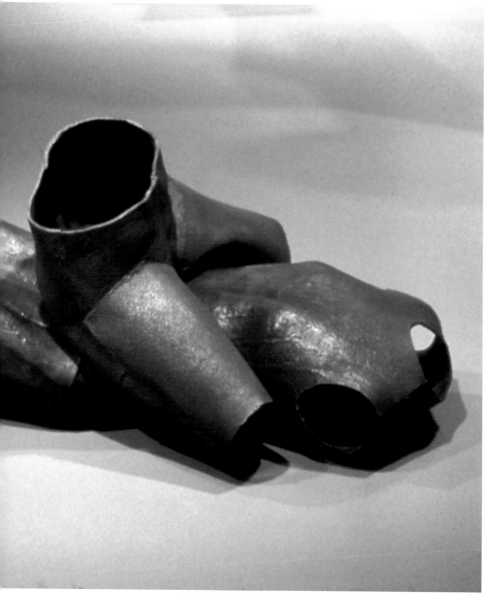

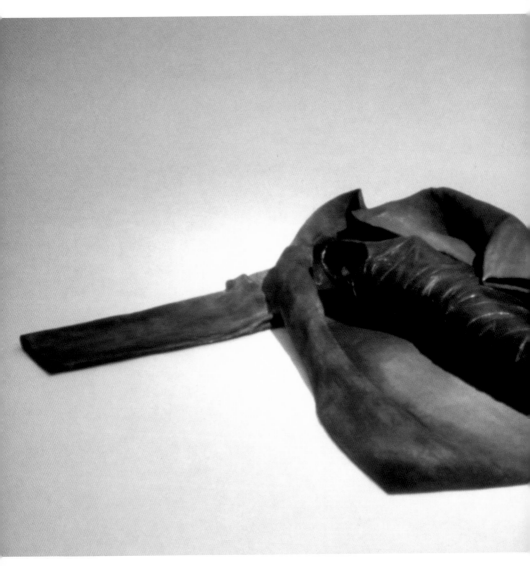

He and She

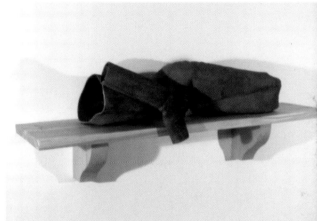

Shelf Piece

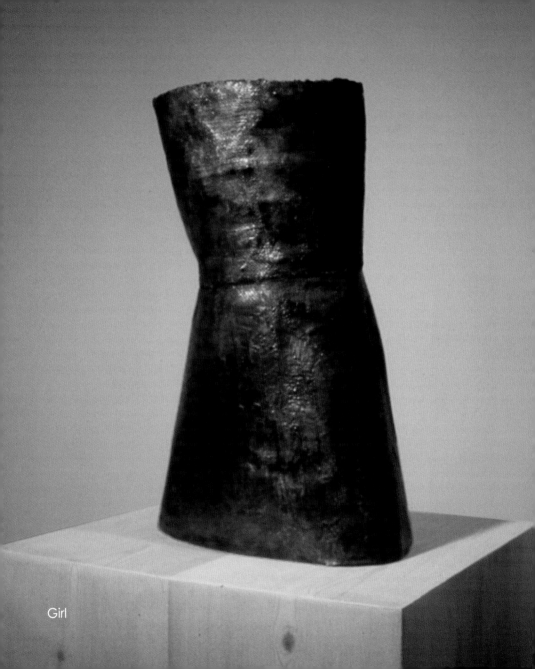

Girl

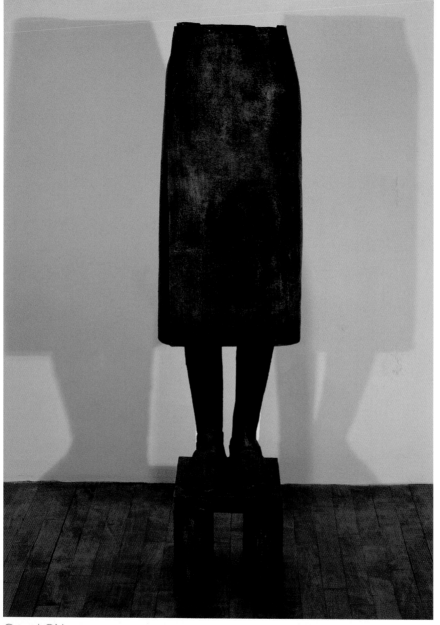

Good Girl

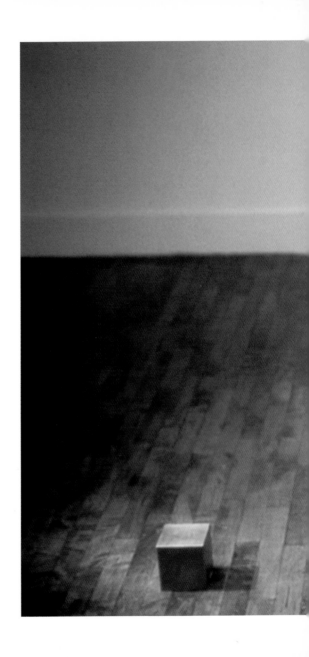

Memento Cubi

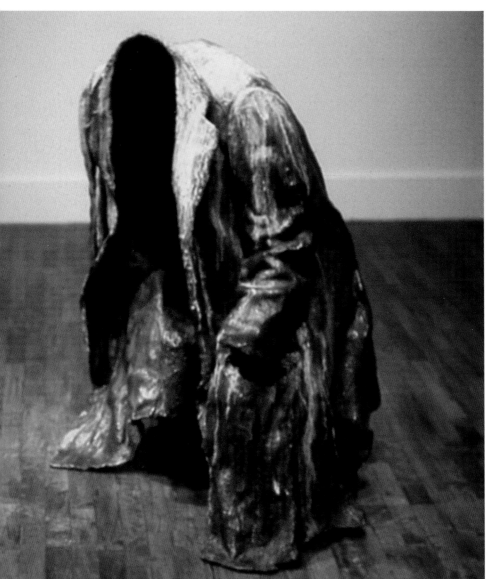

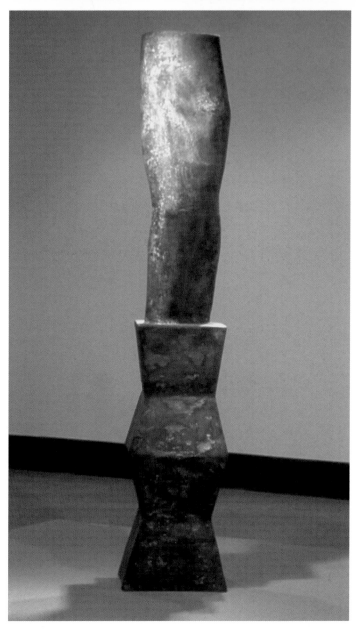

Endless Model

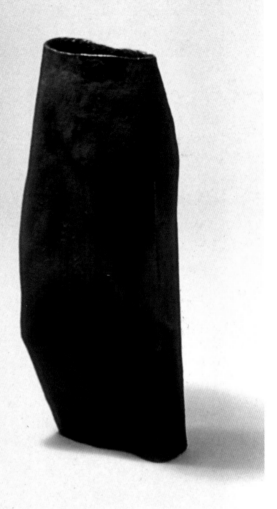

Che Cosa Dice

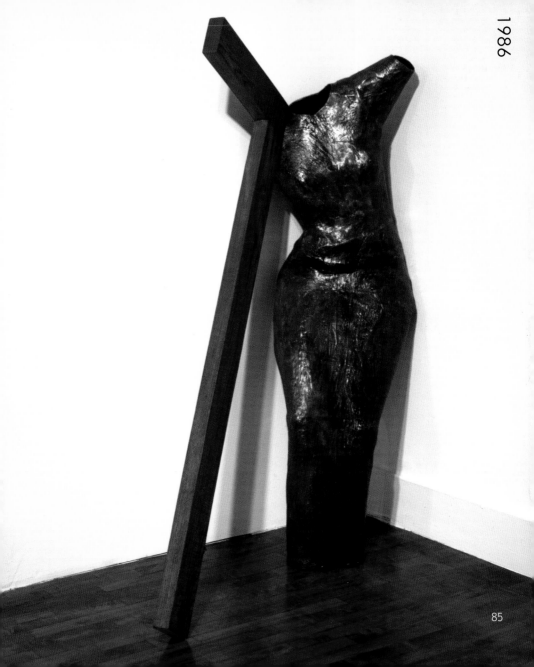

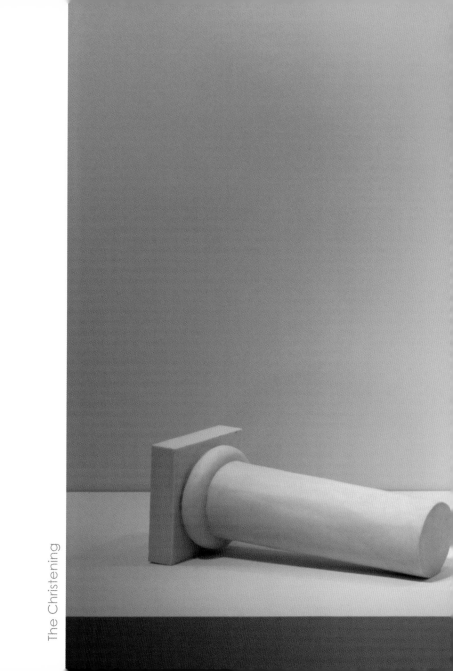

The Christening

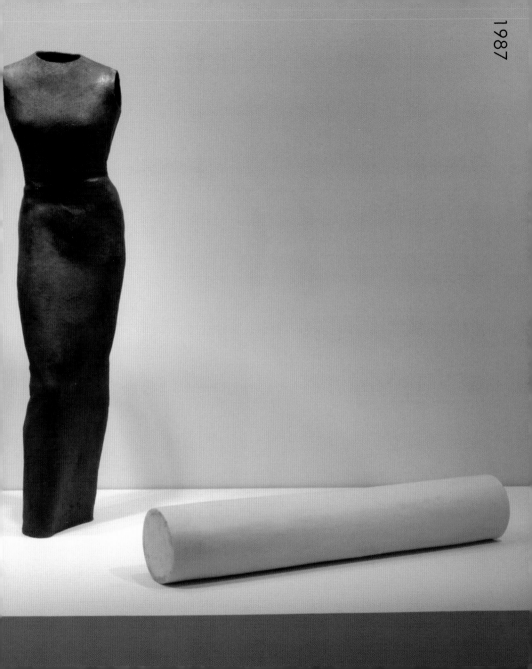

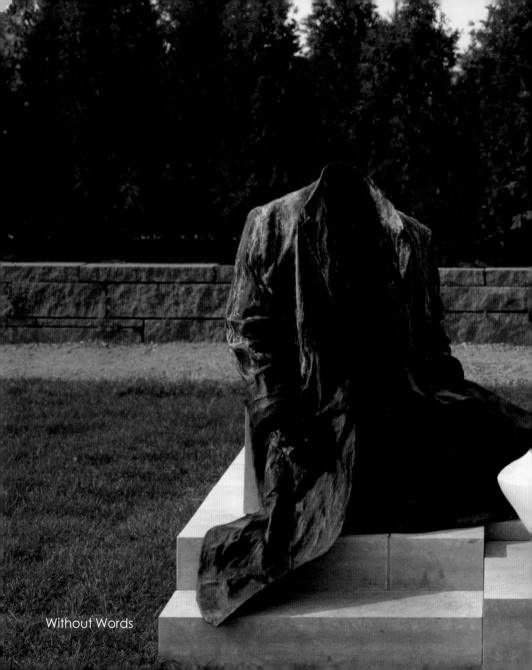

Without Words

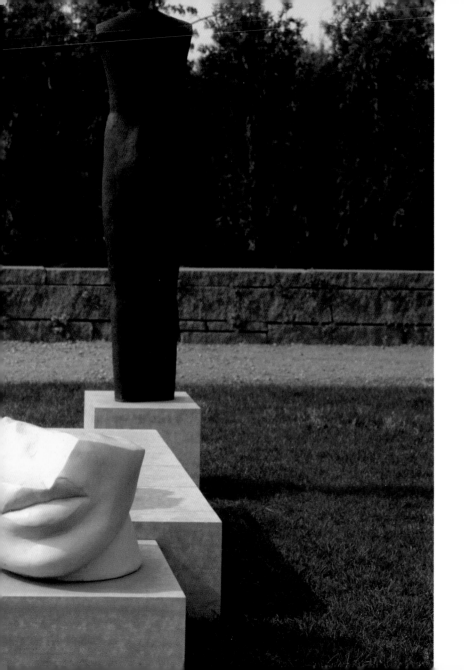

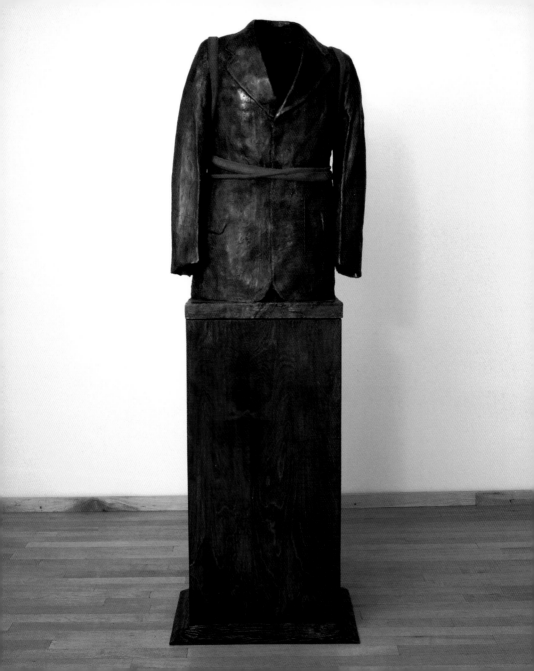

Portrait of a Man

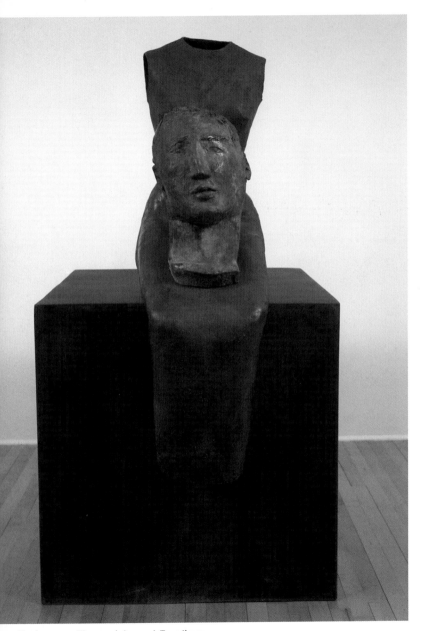

Between Thought and Feeling

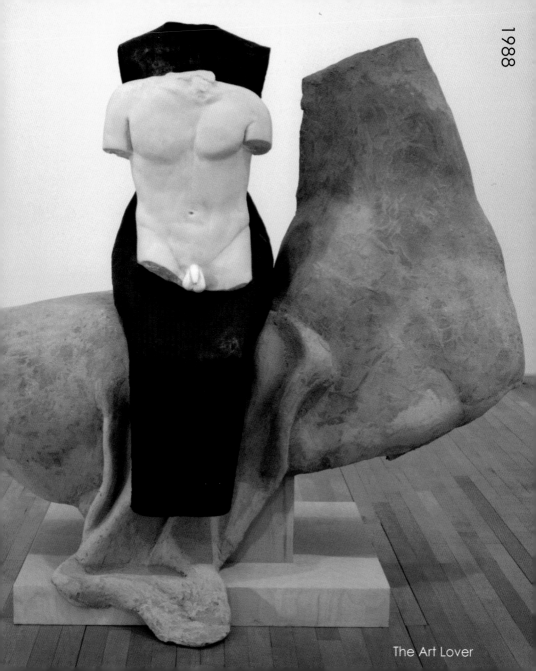

The Art Lover

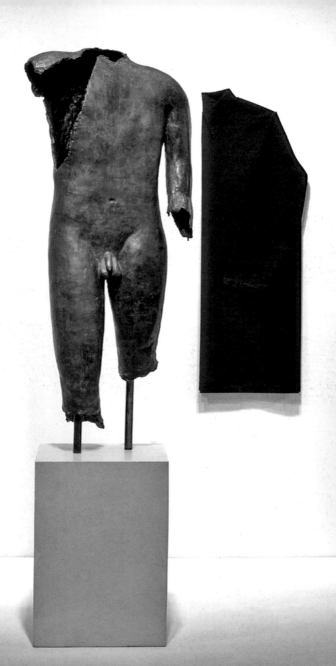

Apollo

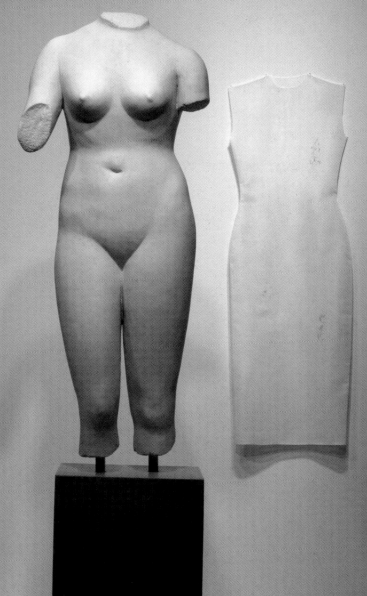

Venus

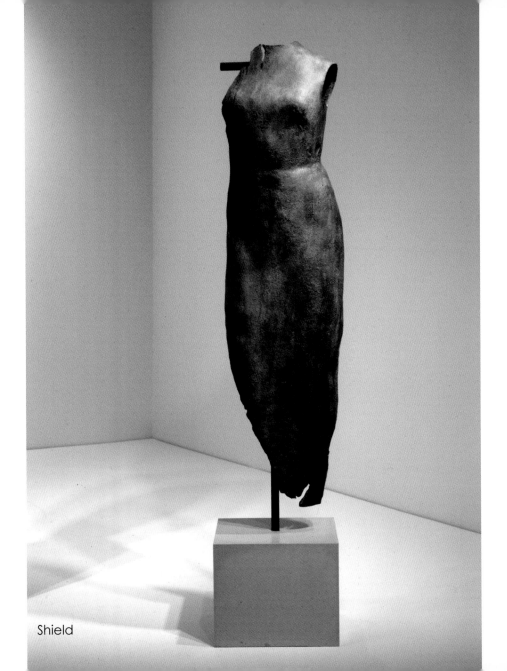

Shield

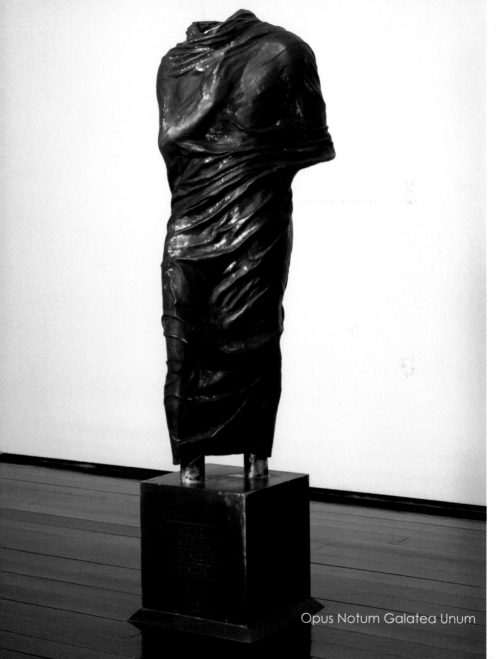

Opus Notum Galatea Unum

Post-Balzac

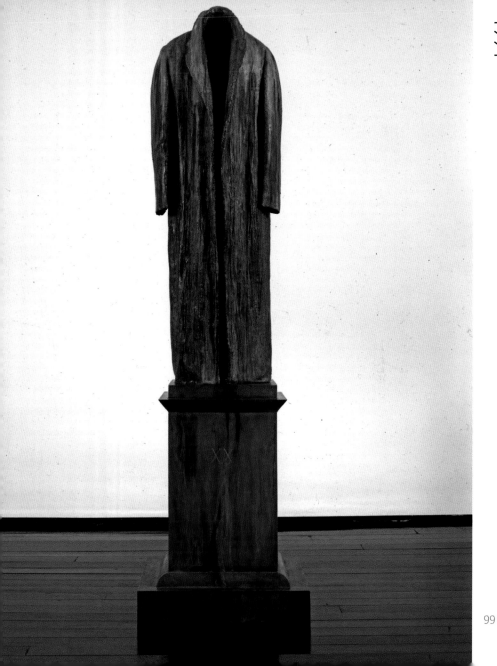

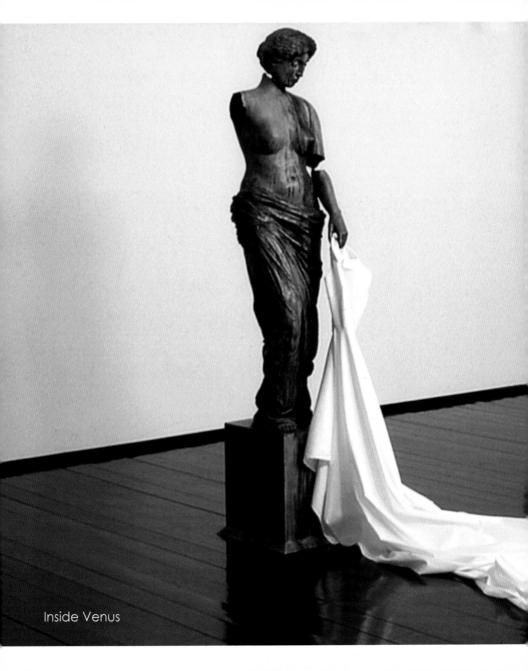

Inside Venus

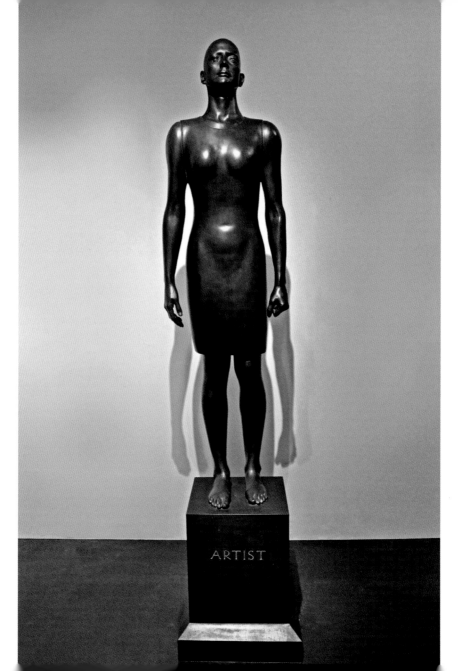

Artist

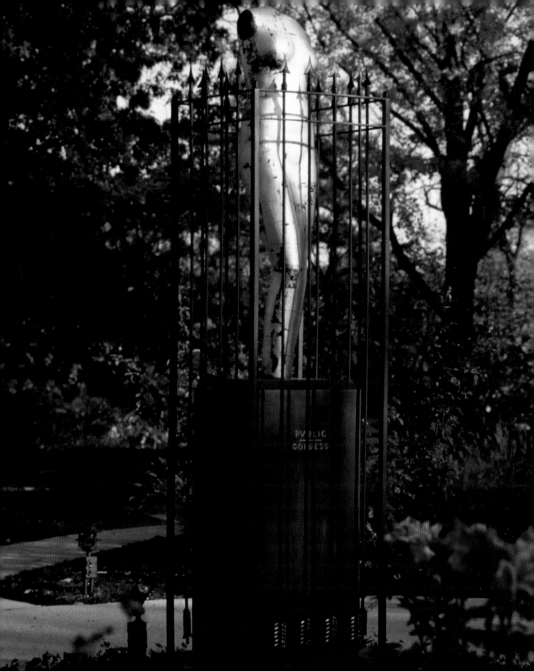

Public Goddess

Storage (m.)

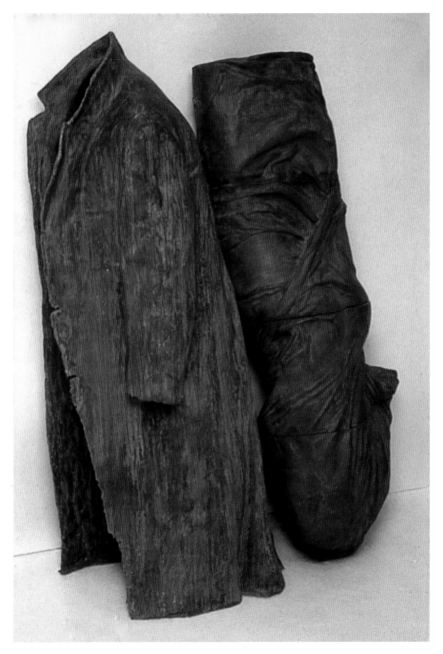

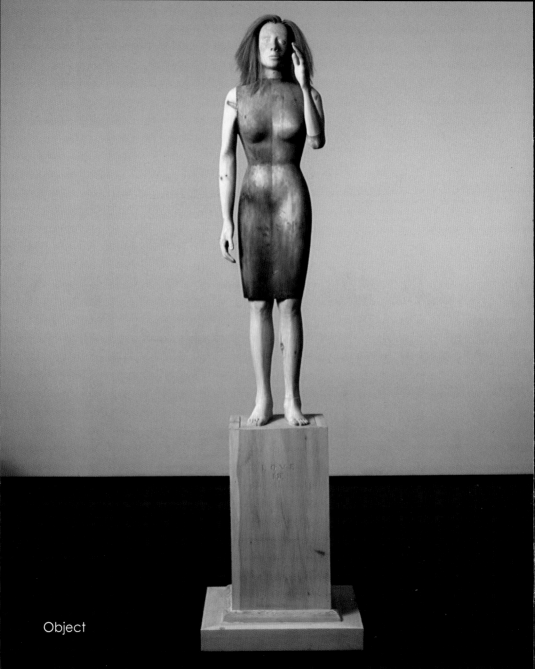

Object

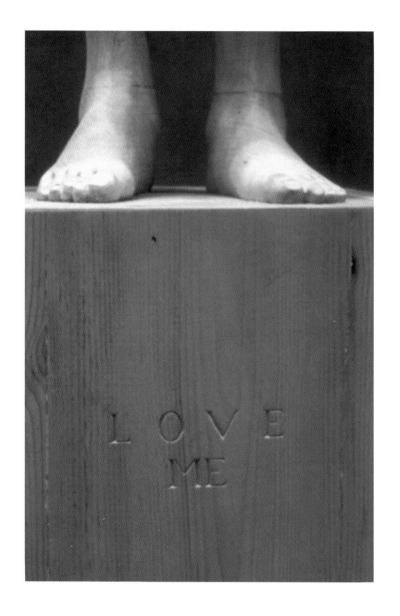

No More Monument

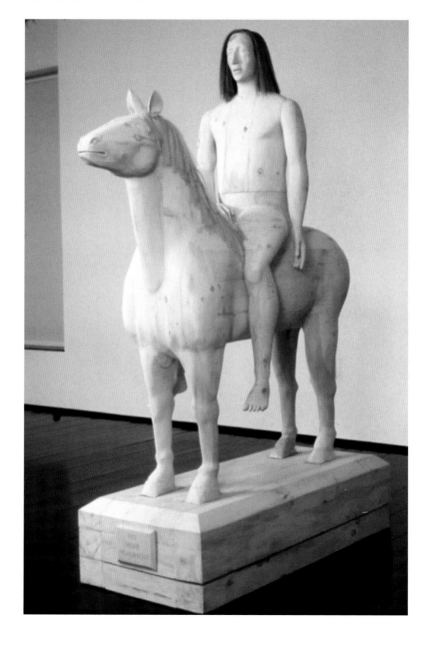

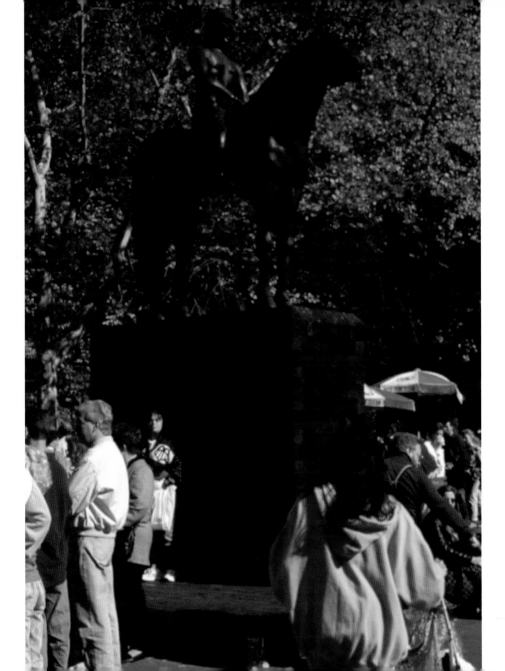

The Other Monument

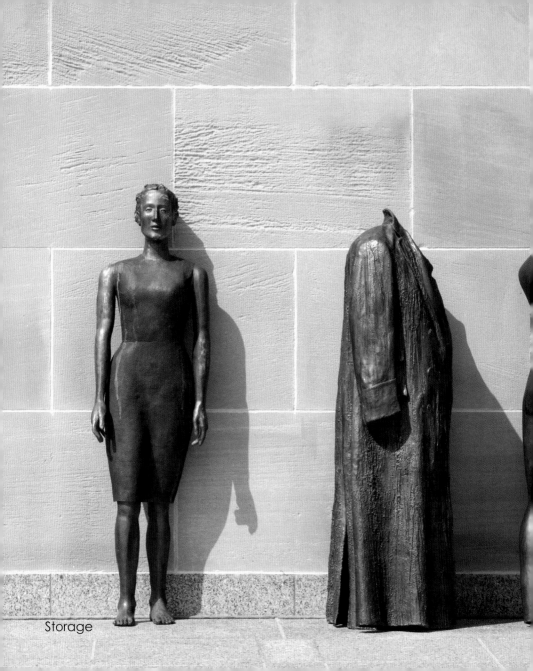

Storage

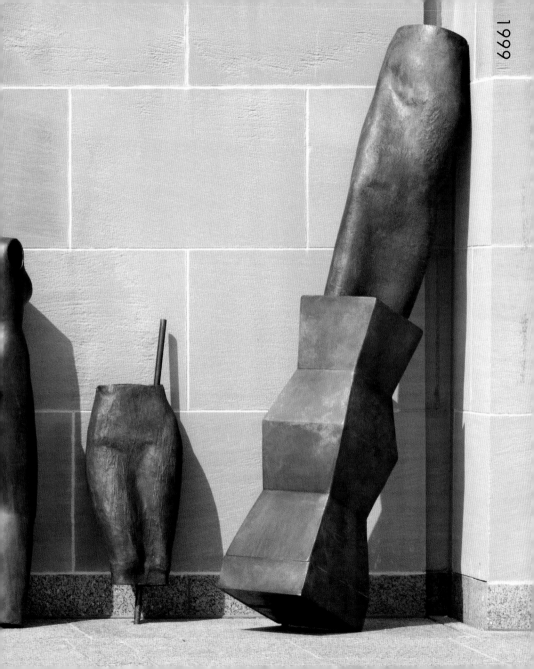

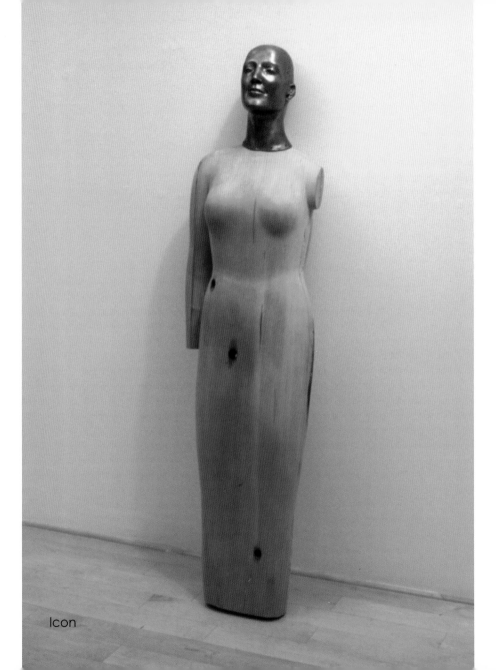

Icon

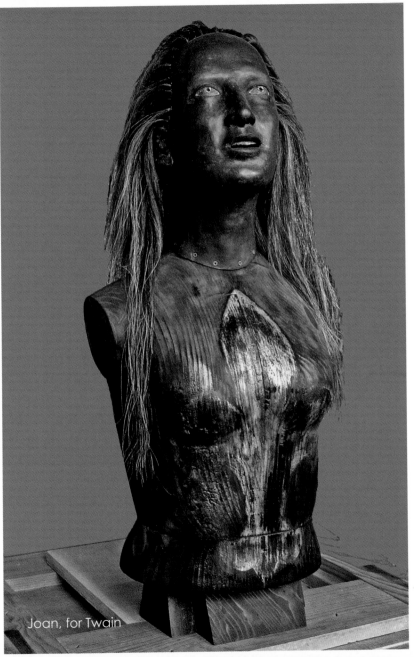

Joan, for Twain

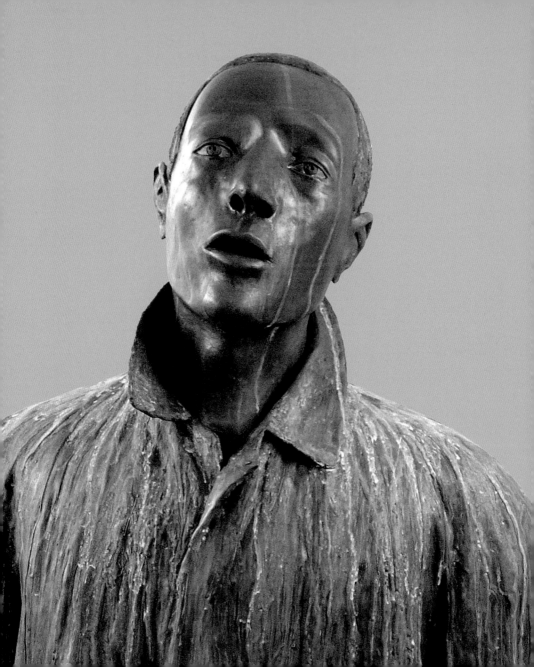

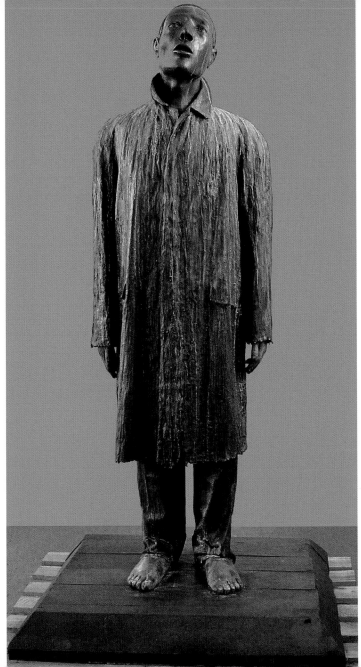

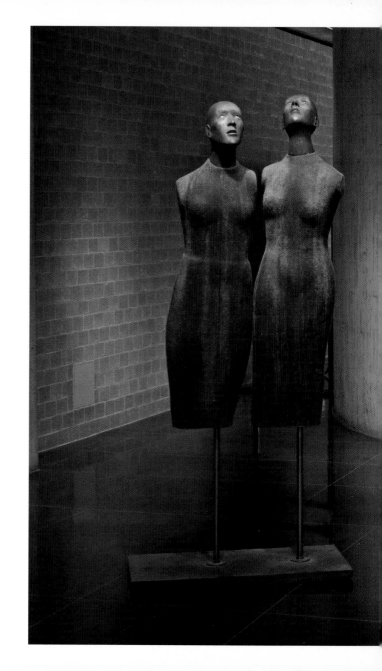

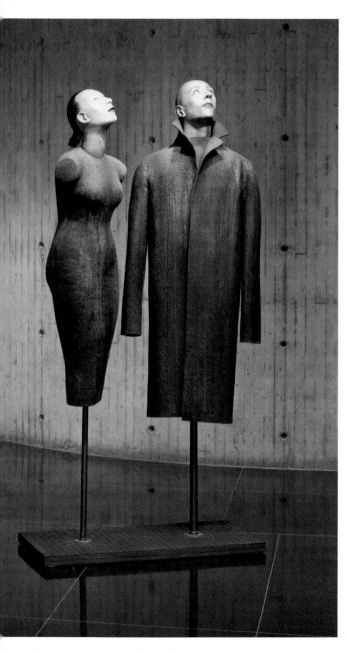

Twins (left and
following page)
Shock and Awe

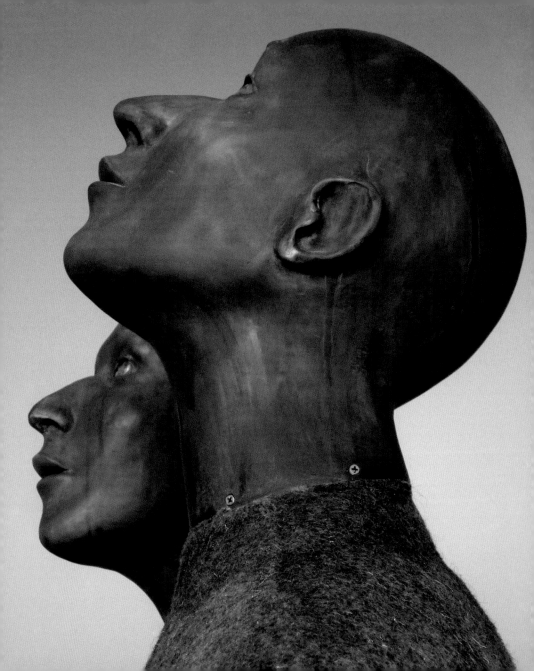

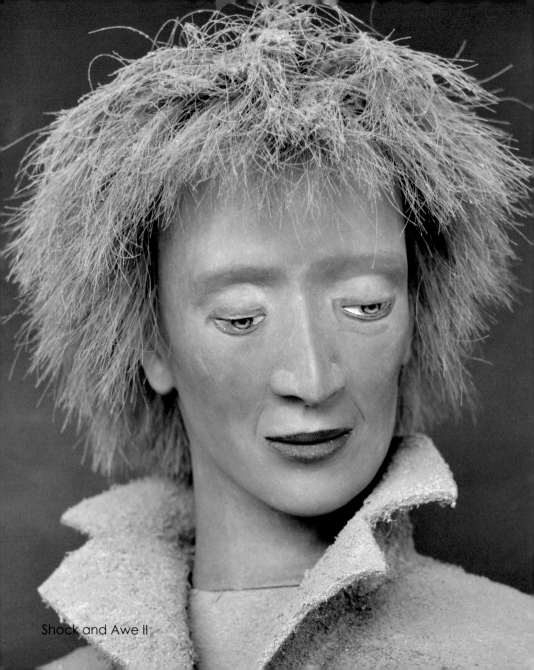

Shock and Awe II

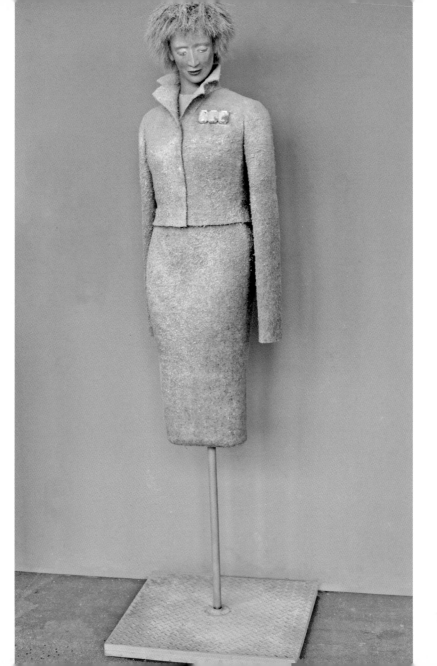

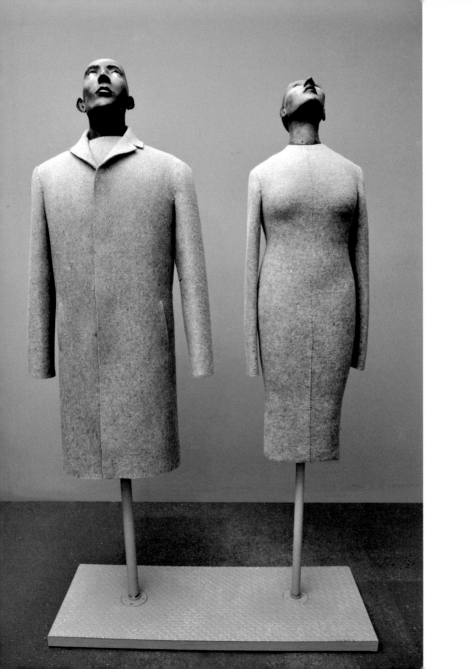

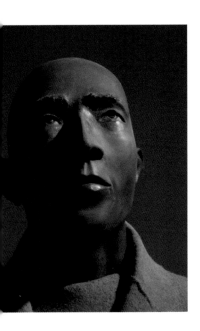

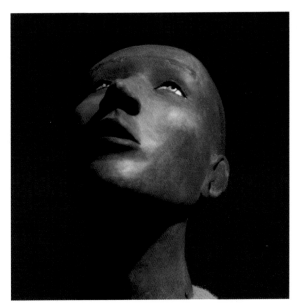

Lower Manhattan Classic

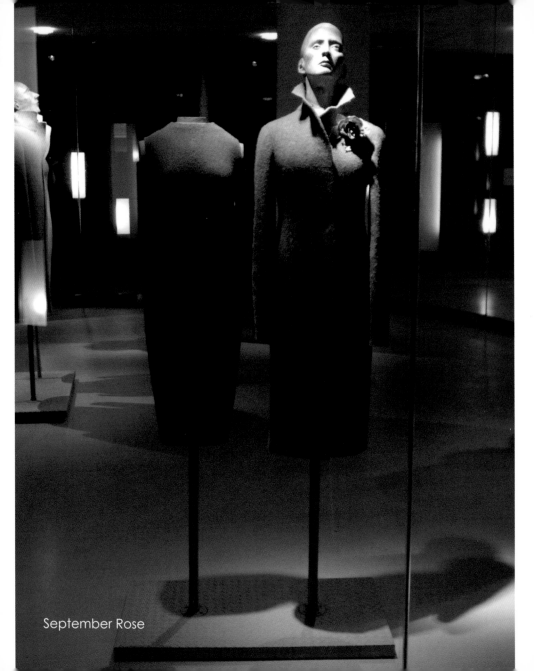

September Rose

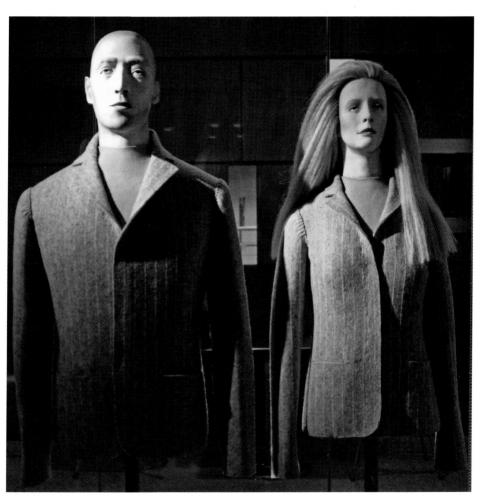

Night Vision

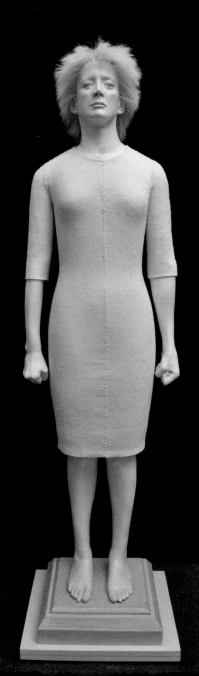

Still Standing

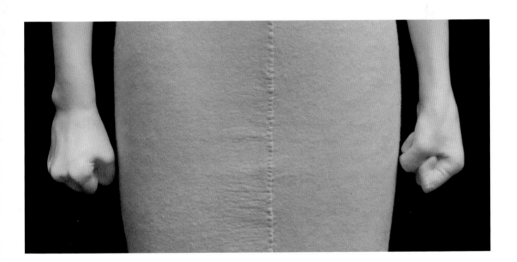

INDEX OF TIMELINE

Artist, 1991–92 102–03
Cast carbon steel
89 1/2 x 18 1/2 x 18 1/2 in.

Public Goddess, 1989–92 104
Bronze, gold leaf, and wrought iron
112 x 32 x 32 in.

Storage (m.), 1992 107
Cast steel
54 x 40 1/2 x 19 in.

Object, 1992 108–09
Wood, stain, paint, and horsehair
100 x 26 1/2 x 26 1/2 in.

No More Monument, 1992–93 111
Wood, stain, and horsehair
84 x 72 x 32 in.

The Other Monument, 1993–94 112
Wood, India ink, and horsehair
112 x 84 x 36 in.

Storage, 1999 114–15
Bronze
13 x 7 x 2 1/2 ft. overall
The Nelson-Atkins Museum of Art, Kansas City, MO
Gift of the Hall Family Foundation, F99-33/77 A-E.
Photo: Jamison Miller

September Rose, 2006–09 128
Carved polystyrene foam, bronze, felt, paint,
wood, MDF, rubber, and steel
75 x 48 x 18 in.

Night Vision, 2006–09 129
Carved polystyrene foam, paper clay, felt, paint,
wood, MDF, rubber, steel,
and synthetic hair
75 x 48 x 18 in.

Still Standing, 2009–11 130–31
Carved polystyrene foam, paper clay, felt, paint,
wood, MDF, and horsehair
70 x 16 x 16 in.

CHRONOLOGY

1969

Graduates from Parsons School of Design, New York, with a degree in fashion design. Although Shea receives awards and distinctions at Parsons, she is more interested in the technical and aesthetic roots of the practice than fashion, or the business of it, and soon returns to her interest in fine art.

1970–73

Works at the United Nations while taking night classes toward her BFA. Her job involves working with international folk art. Shea is moved by this exposure to weaving, masks, dolls, and other traditional forms and takes classes in anthropology to better understand these objects in the context of their cultures.

1975

Receives her BFA from Parsons, which had just recently become a part of the New School for Social Research.

1976

At the invitation of founding director Alanna Heiss, Shea accepts a month-long residency at the Clocktower, New York's first alternative space. Shea creates a performance work that she describes as " living color theory. " She made clothes in transparent colored silks that created a spectrum as she overlaid them on a live model.

Included in Alanna Heiss's *Rooms*, the inaugural exhibition of P.S.1 in Long Island City. For the show Shea creates *King and Queen*, two minimalist robes out of raw canvas that she hangs on the wall. The *Rooms* artists vote for a homecoming king and queen. The winning couple, Dorothy and Herbert Vogel, don Shea's piece for the opening-night "prom."

1977

Receives the first residency at the Fabric Workshop in Philadelphia, which had just been founded by Marion Boulton Stroud to foster cross-disciplinary innovation in fabric design and printmaking. Here Shea prints on fabric and makes her first pattern-inspired piece, *Three Square Shirts* (1977), out of silk-screened cotton hung on wooden dowels, as well as *Four Continents* (1977), out of silk-screened cotton set against a gridded paper.

1979

Creates costumes for Trisha Brown's *Opal Loop*, performed by the Trisha Brown Dance Company, New York.

1979–80

With works like *Bop* (1979–80), *Exec. Sec'y* (1979–80), *I Like Ike* (1979–80)—and continuing with works like *Black Dress* (1982) and *Plumbline* (1982)—Shea turns to fabric pieces that evoke the clothes and ideologies of the 1950s and early 60s, the years of her childhood.

1980

Has her first exhibition at Willard Gallery, where she will show until 1986, when the gallery closes. The show is titled *Clothing Constructions* and is reviewed in both *Art in America* and *Artforum*.

1981

Creates costumes for Trisha Brown's *Son of Gone Fishin'*, performed by the Trisha Brown Dance Company at the Brooklyn Academy of Music.

Creates costumes for Edwin Denby's *Four Plays*, performed by the Eye and Ear Theater Company, New York.

Shea shows *Exec. Sec'y*, *I Like Ike*, and *Inaugural Ball* at the Whitney Biennial. She also has several pieces in the exhibition *Seven Artists* at the Neuberger Museum, State University of New York, Purchase, curated by Laurence Shopmaker.

1982

Creates costumes for Maurice Blanchot's *The Madness of the Day*, performed at La Mama E.T.C., New York.

While preparing a lecture for a class she was teaching at the Costume Institute of the Metropolitan Museum of Art, Shea discovers a collection of glass slides that had been assembled by Bashford Dean (1867–1928), who had been Curator of Arms and Armor at the Met. Inspired by an image among them of the remains of a Crusader's medieval iron cuirass, Shea would begin to make work cast in iron, and later bronze.

1983

Included in the Hirshhorn Museum and Sculpture Garden's *Directions 1983* exhibition, curated by Phyllis Rosenzweig, where she shows a series of cloth pieces constructed of felt and canvas, including *O Kazimir* (1981).

1984

Receives an NEA Individual Artist's Fellowship in Sculpture.

Exhibits at the Walker Art Center in *Viewpoints*, a two-person show (with Nick Vaughn) curated by Marge Goldwater. Shea shows new cast iron and bronze works, including *Crusader* (1982) and *Crawl* (1983).

1985

Exhibits recent sculpture at the Hayden Gallery, M.I.T. List Visual Arts Center, Cambridge, in a two-person show (with Robert Moskowitz)

curated by Katy Kline. Works include *Peplum* (1982), *Crawl* (1983), *Acting Out* (1984), *He and She* (1984), *Shelf Piece* (1984), and *Standing There* (1984).

1986

Awarded a second NEA Fellowship in Sculpture, this time with the addition of a French exchange program. Shea travels to France, where she studies statuary and monuments in the parks and gardens of Paris and environs. She goes on to London to study monument statuary there. These trips mark the beginning of Shea's research into the full-scale figure situated in the landscape, which by the end of the decade would culminate in several works sited in gardens and public spaces, including *Eden* (1986) at the Museum of Contemporary Art San Diego, *Shepherd's Muse* (1986–89) at the Oliver Ranch, and *Without Words* (1988) at the Walker Art Center. Later outdoor installations include *Shield* (1989), which was included in a Rose Garden exhibition at the White House initiated by First Lady Hillary Clinton, and *Post-Balzac* (1990–91), on view in the Hirshhorn Museum's Sculpture Garden on the National Mall in Washington, D.C.

1988

Judith Shea, a ten-year survey of Shea's work curated by Lynda Forsha, opens at the La Jolla Museum of Contemporary Art, and then travels to the University Gallery, University of Massachusetts, Amherst.

1989

Judith Shea: Horizons, curated by Deborah Emont Scott, opens in February at the Nelson Atkins Museum of Art in Kansas City. Works shown include *Endless Model* (1987–88), *Between Thought and Feeling* (1988), and *Portrait of a Man* (1988).

Sculptor-in-Residence Fellowship at Chesterwood, the historic summer

home and studio of Daniel Chester French, in Stockbridge, Massachusetts. While at Chesterwood, Shea takes up wood carving.

1991

Exhibits recent works in *Judith Shea's Monument Statuary* at Max Protetch Gallery, including *Post-Balzac* (1990–91), *Inside Venus* (1990–91), and *Opus Notum Galatea Unum* (1991).

1992

Judith Shea: Monuments and Statues, curated by Thelma Golden, opens at the Whitney Museum of American Art at Phillip Morris. Along with *Post-Balzac*, *Opus Notum Galatea*, and *Inside Venus*, Shea shows her first full-scale carved wooden piece, *Object* (1992).

Public Goddess (1992) is permanently installed at the Laumeier Sculpture Park in St. Louis, in conjunction with their show *On a Pedestal: Judith Shea, Public Goddess and Other Works*.

1993

Exhibits four new figures carved in pine in *Judith Shea: All about Adam, and Eve* at the Max Protetch Gallery, including *Object* and an equestrian figure titled *No More Monument* (1992–93). Shea also shows *Artist* (1991–92), a figure in cast steel representing the missing presence of female artists in the pantheon of sculptors.

No More Monument is commissioned for the new Pennsylvania Convention Center in Philadelphia.

Honored by the City of New York for "Outstanding Volunteer Service with the Artists and Homeless Collaborative." Shea also receives a Rockefeller Foundation Residency at the Bellagio Study Center in Bellagio, Italy, as well as the Fellowship of the Saint-Gaudens Memorial at the Saint-Gaudens National Historic al Site in Cornish, New Hampshire.

Creates costumes and sets for *Fields of View*, performed by Susan Marshall and Company at the Brooklyn Academy of Music.

1994

The Other Monument, a larger than life-scale, hand-carved, wooden equestrian statue of a black man on a black horse, is installed in New York's Doris Freedman Plaza by the Public Art Fund, just behind the monument to General William Tecumseh Sherman by Augustus Saint-Gaudens.

Receives the Rome Prize of the American Academy in Rome, residing in Rome from September 1994 through the following June.

1995

Receives the Lila Wallace–Reader's Digest International Artist Award, with a residency in Oaxaca, Mexico, where Shea spends seven months.

Around this time, Shea's work in wood carving is temporarily interrupted because of a respiratory problem caused by exposure to toxic materials.

Included in *Arte/Moda: Prima Biennale di Firenze*, held at Forte Belvedere in Florence and curated by Germano Celant and Ingrid Sischy. Shea is represented by several works, including *Checked Pants* (1977), *Three Square Shirts* (1977), and *Inside Venus* (1990–91).

1997

Arte/Moda comes to New York as *Art/Fashion* at the Guggenheim Museum Soho.

1999

Completes a five-figure bronze piece, *Storage*, for the sculpture garden of the Nelson Atkins Museum of Art.

2000

Influenced by her travels in Italy and Mexico, begins a group of figures roughly based on representations of saints.

2004

Judith Shea: Statues, at the John Berggruen Gallery in San Francisco, includes *Joan, for Twain* (2000) and *Urban Francis* (2000–03).

2006

Shea begins work on a group of figures that grew out of her experience of 9/11. Shea's home is very near Ground Zero, and she was there when the planes struck the Twin Towers. In the weeks that followed, reflections in the empty, but unshattered, store windows of the Brooks Brothers store across from Ground Zero became for Shea a metaphor for the tension between American style and success and the forces that sought to lay it low.

2007

Receives the Charlotte Dunwiddie Prize for Sculpture from the National Academy Museum in New York for *Apollo* (1989).

2009

The 9/11 series, titled *Judith Shea: Legacy Collection*, is shown at the Brooklyn campus of Long Island University. The exhibition includes *Twins* (2006–07), *Shock and Awe* (2006–09), *Lower Manhattan Classic* (2006–09), *September Rose* (2006–09), and *Night Vision* (2007–09).

2010

Returns to Chesterwood as emeritus Sculptor-in-Residence.

2011

Yale University Art Gallery shows works they have acquired from the *Judith Shea: Legacy Collection series.*

Receives the Anonymous Was a Woman Award.

Receives the Artists' Legacy Foundation Artist Award.

2012

Receives the John Simon Guggenheim Memorial Foundation Fellowship in Fine Arts.

As part of its tradition of inviting member artists to assemble a show from its collection, the National Academy Museum in New York asks Shea to curate an exhibition. For the resulting show, *Her Own Style: An Artist's Eye with Judith Shea*, she assembles self-portraits and portraits of female academicians over the institution's history, shown with her own *Artist* (1991–92), *Still Standing* (2009–11), and *Louise Monument: Portrait of Louise Bourgeois* (2012), as well as the still in-progress *Elizabeth Tribute: Portrait of Elizabeth Catlett.*

2013

Receives the Award for Excellence: The 2013 Annual Exhibition from the National Academy Museum.

Receives the Arts and Letters Award in Art from the American Academy of Arts and Letters.

SELECTED PUBLIC COLLECTIONS

Addison Gallery of American Art, Phillips Academy, Andover, MA
Albright-Knox Art Gallery, Buffalo, NY
Brooklyn Museum
Dallas Museum of Art
Des Moines Art Center, Des Moines, IA
Hirshhorn Museum and Sculpture Garden, Washington, DC
Laumeier Sculpture Park, St. Louis, MO
The Metropolitan Museum of Art, New York
Museum of Contemporary Art San Diego, La Jolla, CA
The Museum of Fine Arts, Houston
Museum of Modern Art, New York
National Academy Museum, New York
National Gallery of Art, Washington, DC
The Nelson-Atkins Museum of Art, Kansas City, MO
Santa Barbara Museum of Art, Santa Barbara, CA
Sheldon Museum of Art, University of Nebraska, Lincoln
Walker Art Center, Minneapolis, MN
Weatherspoon Art Museum, University of North Carolina, Greensboro
Whitney Museum of American Art, New York
Yale University Art Gallery, New Haven, CT